CREATING
CONCRETE ART FURNITURE

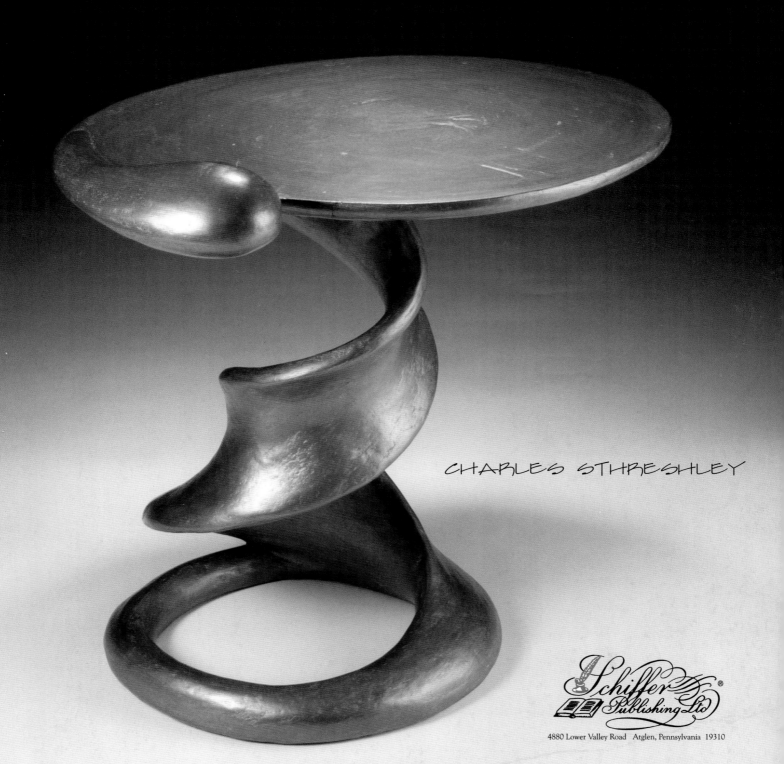

CHARLES STHRESHLEY

Schiffer Publishing Ltd

4880 Lower Valley Road Atglen, Pennsylvania 19310

DEDICATION

This book is dedicated to my niece Lisa, for her love of books, and to my nephew Michael for his curiosity about nature. His examination of insect forms inspired me to design the *Fly Table*.

Other Schiffer Books on Related Subjects
Arts & Crafts Concrete Projects. Pedro J. Lemos & Reta A. Lemos.
Making Concrete Countertops. Buddy Rhodes with Susan Andrews.
Built to Last: A Showcase of Concrete Homes. Tina Skinner.

Copyright © 2008 by Charles Sthreshley
Library of Congress Control Number: 2007941941

Type set in Bernhard Modern BT/News Gothic BT

ISBN: 978-0-7643-2873-2
Printed in China

Schiffer Books are available at special discounts for bulk purchases for sales promotions or premiums. Special editions, including personalized covers, corporate imprints, and excerpts can be created in large quantities for special needs. For more information contact the publisher:

Published by Schiffer Publishing Ltd.
4880 Lower Valley Road
Atglen, PA 19310
Phone: (610) 593-1777; Fax: (610) 593-2002
E-mail: Info@schifferbooks.com

For the largest selection of fine reference books on this and related subjects,
please visit our web site at **www.schifferbooks.com**
We are always looking for people to write books on new and related subjects. If you have an idea for a book please contact us at the above address.

This book may be purchased from the publisher.
Include $3.95 for shipping.
Please try your bookstore first.
You may write for a free catalog.

In Europe, Schiffer books are distributed by
Bushwood Books
6 Marksbury Ave.
Kew Gardens
Surrey TW9 4JF England
Phone: 44 (0) 20 8392-8585; Fax: 44 (0) 20 8392-9876
E-mail: info@bushwoodbooks.co.uk
Website: www.bushwoodbooks.co.uk
Free postage in the U.K., Europe; air mail at cost.

CONTENTS

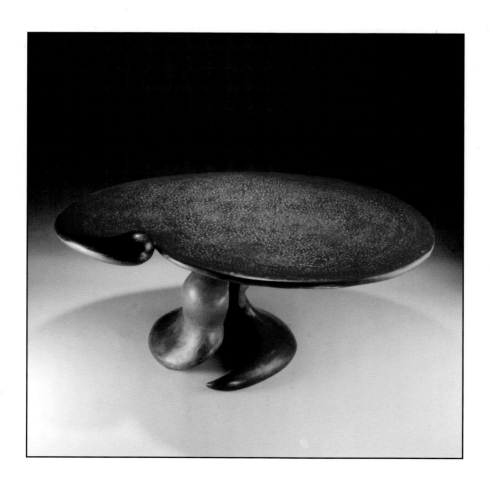

ACKNOWLEDGMENTS

I would like to thank my mother, Flo Sthreshley, for her encouragement and for proofreading the text. I am also grateful to Eleanor Wallace and Ralph Logan for proofreading with a critical eye. I offer my special thanks to Marty Jones for her support in moving concrete furniture for photographing, proofreading, and letting me include a photo of her plant stand. I am honored that Schiffer Publishing has given me this opportunity to share my direct concrete technique and concrete art furniture with a wider audience. It has been my pleasure to work with the talented staff of Schiffer Publishing, Jeffrey B. Snyder, the Editor, and especially Tina Skinner who proposed this book.

DISCLAIMER

INTRODUCTION

This book is intended to inspire and challenge artists to use concrete as a fine art material. It should also serve as a reference for some of the many methods and technical possibilities. It is not expected that the reader will make a copy of the table illustrated, but that this information will spark the imagination and provide a means for their own creativity. In this project as many of the various creative effects are presented as possible in one piece. It shows what can be done with this method and also encompasses as many technical aspects as may be encountered. For further inspiration, those excited by the creative potential of concrete will be drawn into a rapidly growing network of artists that share their discoveries and enthusiasm.

Furniture created in concrete is practical, permanent, ecological, and economical. The Direct Concrete Technique illustrated in this book empowers anyone to make furniture or sculpture by hand without molds or forms. The key to this method is the use of a steel armature covered with wires. Bold and elegant designs of lightweight curvilinear elements can be fashioned with this system. The advantages of concrete and the direct technique are numerous, and the results are immediate and durable. Artwork made directly in concrete can be modified and refined by both additive and subtractive processes so that the creative potential is extended throughout construction. The main ingredients, sand and water, are abundant and inexpensive and cement and steel are readily available. The equipment and tools necessary are few and the technique is easily mastered.

In designing for any medium, first define the client, purpose, and relevant criteria. For this project we will assume the clients are people who want to entertain outdoors, perhaps on their deck or patio. They need a small table to put food and drinks on. They want to use the table like an end table between two chairs, to create an intimate conversation area away from a main activity area. It ought to be casual, fun, festive, and perhaps a bit quirky to spark conversation. The table needs to be mobile, sturdy, and weather-resistant. Concrete is such a material and can be mobile if casters are designed as part of the legs.

Concrete and steel, the materials for ferrous-cement, are heavy, so the challenge is to design furniture that doesn't look or feel heavy. Steel contributes the tensile strength to ferrous-cement. The secret to designing is to visualize the linear steel reinforcement bars as lines in space, and then to "draw in space" with steel. When the armature is covered with concrete it will retain the thin and linear elements and will look light and active, like it is emerging out of the *air*.

Begin by making small drawings that consider relevant criteria. Explore structural issues like mobility and research the typical height of end tables. Search for a thematic concept that will spark interest and make this piece unique.

Eventually, there is a breakthrough and a theme is developed. What would be more discouraging to outdoor entertaining than pests...flies and mosquitoes? Appease the curse, with a totem to insects! Make a table that looks like a big fly. By acknowledging and making light of the pest, the guest may be more inclined to accept nature.

With an insect theme for the *Fly Table*, design the top surface as wings folded one over the other. Make the back two legs spring forward on casters to strike an alert pose. The front leg can be like a stinger of a mosquito. The head made up of two large bulbous eyes that form an opening that is used as a handle for lifting the front leg/stinger, so that the back legs can roll forward.

Make full size drawings on kraft paper of the side elevation and the top plan. The average height of end tables is twenty-one inches, so begin with this fixed dimension on the elevation. Draw a twenty-one-inch square and try different proportional systems to relate the legs to the top surface. The geometric proportional system (where AB is to AC as AC is to AD) works well with the *Fly Table*. Test the proportions by making a small model of wood. Analyze the model and make adjustments in the design. Make a working pattern from the full size drawing by copying the contours to another piece of kraft paper. An old method of poking a straight pin through the full size drawing into the working pattern and then connecting the holes is effective. Cut out the working patterns and tape them to a concrete floor. Draw around the pattern on the floor with a welder's soapstone marker or a carpenter's pencil.

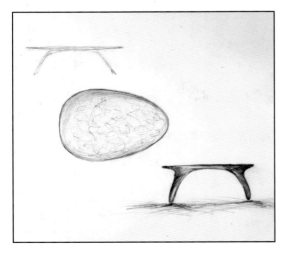

Conceptual Drawing: The first drawing is small, only a few inches, and is drawn with a pencil so that it can be easily modified and refined.

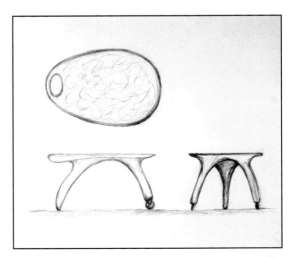

Second Drawing: The top surface is egg-shaped, a reference to a new beginning. The wheels on the back legs are for mobility and a hand hole to lift the front leg for moving, are features that become part of the final design.

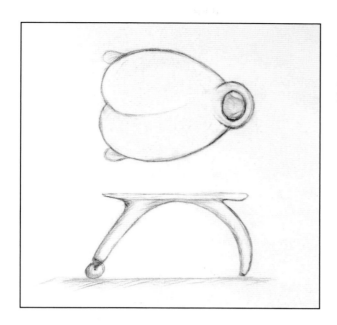

Production Drawing: This drawing has all the major components of the table; an insect-like form with wings for the top surface and a head that functions as a lifting hole. The front leg has an arched curve ending in a rubber cane tip. The back legs extend beyond the top to give the *Fly Table* a feeling of forward motion and alertness.

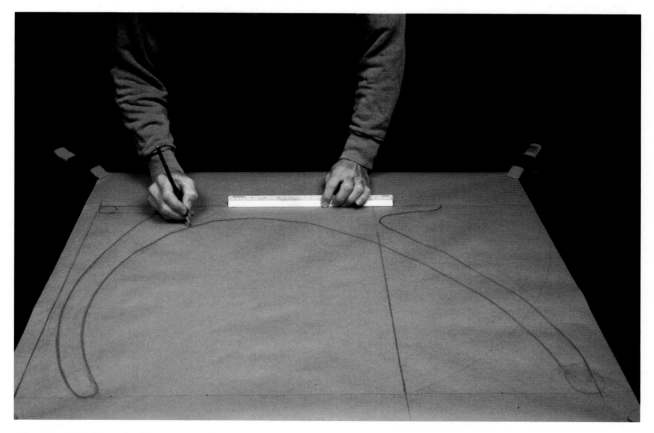

Elevation: The ideas in the conceptual drawings are worked out to full size on brown kraft paper.

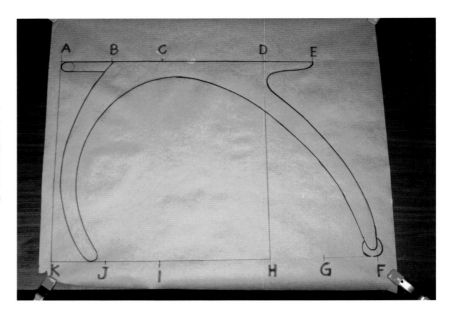

Proportional System: The proportions are determined by the twenty-one-inch height typical of occasional tables. First a twenty-one-inch square is drawn between points A, D, H, and K. The geometric progression system (where AB is to AC as AC is to AD) is used to determine both where the legs end and size of the head.

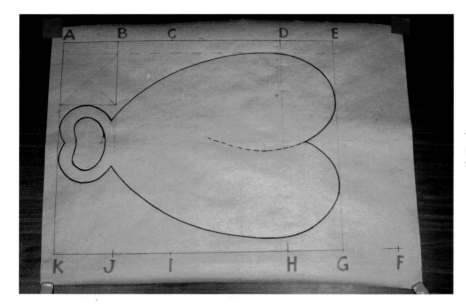

Top Plan: The top is drawn using the same proportional system as the side elevation.

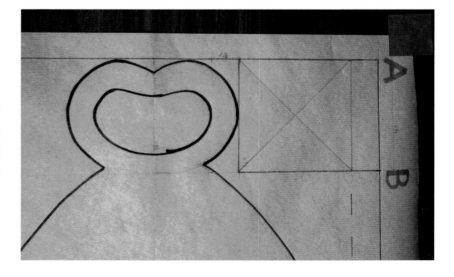

Top Plan Detail: The hand hole has been modified, from an oval in the conceptual drawing to symmetrical bulbous forms that resemble the eyes of an insect. This adds character and mimics the back end of the wings while still retaining the function of a handle.

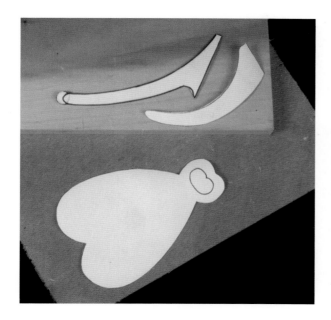

Model Pattern: Three dimensional models are used to work out design solutions, primarily how components relate to each other. Pictured on a board are the paper patterns for the legs. The top model pattern is on a quarter-inch piece of plywood.

Shaping the Legs of the Model: Use a wood rasp to shape the soft poplar back legs of the model. The finished front leg is shown to the left.

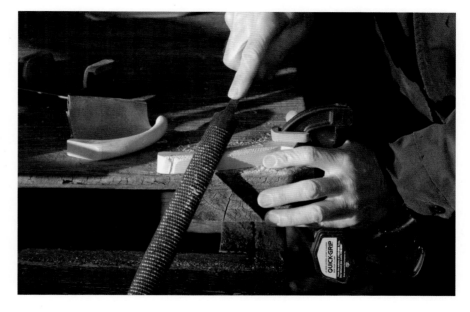

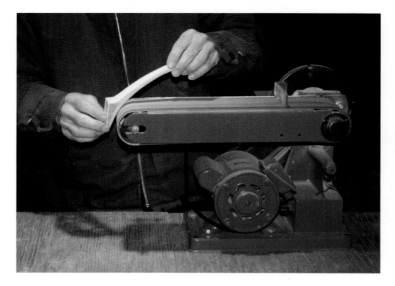

Sanding a Leg: A small combination sander with a six-inch sanding disk and four inch wide sanding belt is utilized for shaping and smoothing parts of the model.

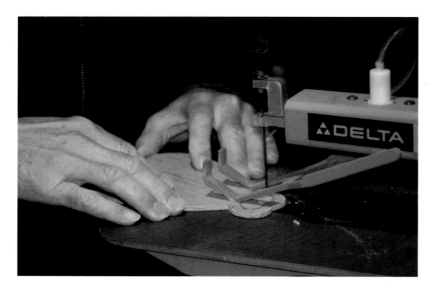

Cutting Out the Model's Top: Trace the top pattern for the model on quarter-inch plywood and cut it out with a scroll saw. Next drill a hole where the hand hole is, then disconnect the scroll saw's blade. Put the blade through the hole, reinstall the blade, and cut out the model's hand hole. Secure the legs to the top with carpenter's glue.

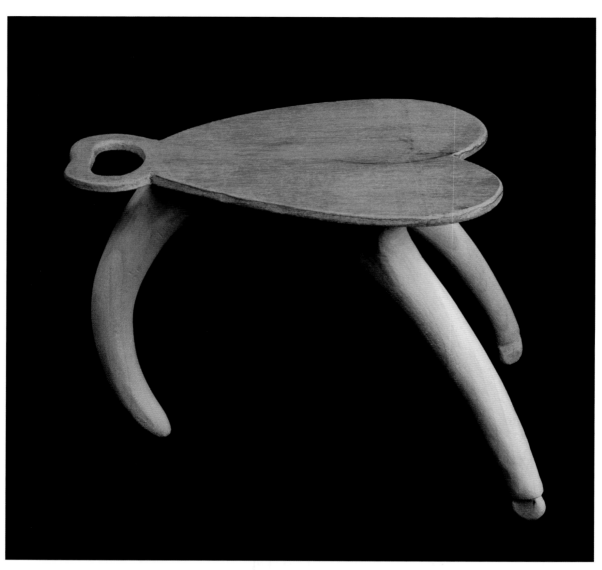

Analyzing the Model: After assessing the proportion, it was determined that the top needs to be bigger, because the back legs trail too far behind the table and could be a tripping hazard.

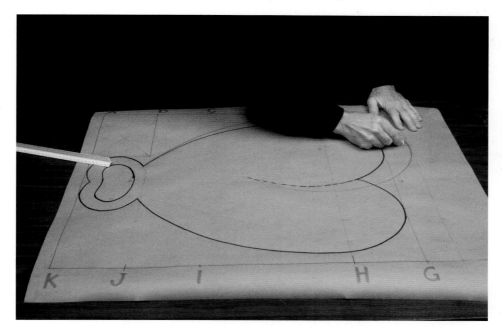

Freehand Drawing: A new back contour is drawn freehand on the top plan pattern that is a half unit larger towards the back.

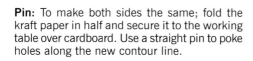

Pin: To make both sides the same; fold the kraft paper in half and secure it to the working table over cardboard. Use a straight pin to poke holes along the new contour line.

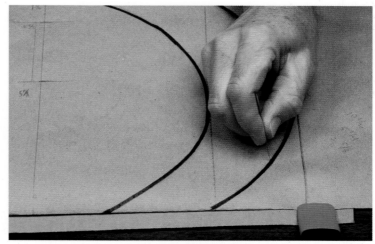

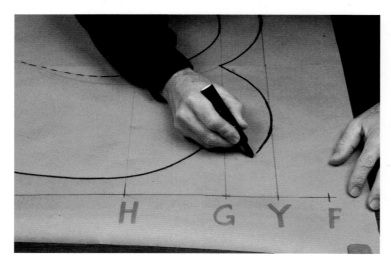

Tracing the Pin Marks: Unfold the pattern and trace the pin holes with a dark marker.

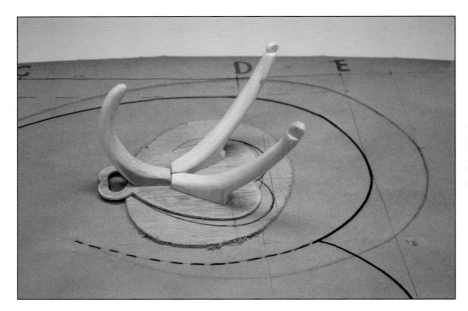

Making Another Top for the Model: With the model upside down on another piece of plywood, draw a larger contour, and cut out the new top.

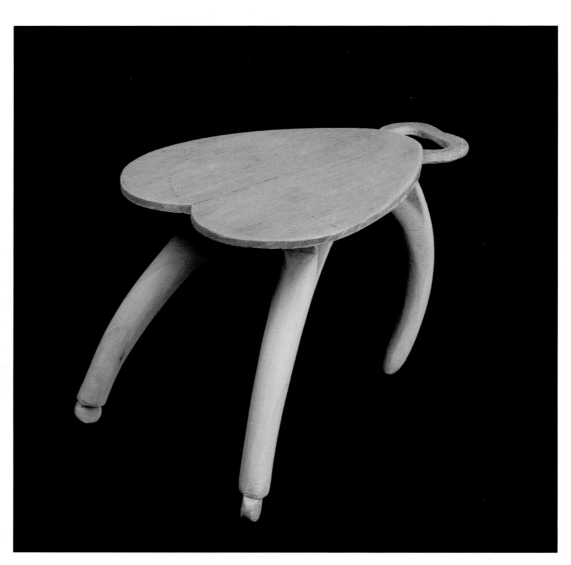

Analyzing the Model: Analyze the model with its new top and determine if safety, esthetics, and structural criteria are met.

Transferring to a Working Pattern: Use the pin method of piercing to transfer elements such as the legs to another paper pattern so the original can be preserved for reference.

Cutting out the Pattern: For the top plan, where both sides are symmetrical, use the pin method of piercing half the pattern. Retrace the pierced half of the second working pattern, fold it in half, and cut out both halves together.

Tape and Trace Pattern on Studio Floor: Tape the patterns on a concrete floor and trace the patterns with a welder's soapstone marker or a carpenter's pencil.

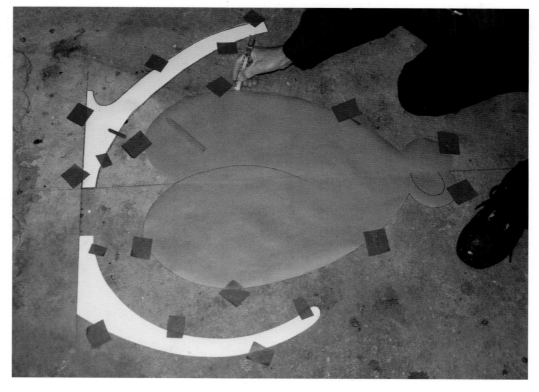

13

CHAPTER TWO
METALWORK: FIRE

Fabricating the armature is the process where the concept starts to becomes reality. Steel reinforcement bars (re-bars) are shaped in three dimensions like "drawing in space." It is the most exciting, challenging, but also dangerous phase. You must be alert to when something is not working out as envisioned, follow your intuition, and be flexible enough to be open to change. It is important to constantly be thinking ahead several steps, especially anticipating how various elements like the legs of the table are going to be attached to the tabletop. Choices are made about acceptable tolerances, the structure's engineering, and the esthetics.

Fire, the subtitle, refers to the Vulcan-like activities of shaping and welding hot metal. The Fly Table project illustrated here is challenging and requires some skill in welding and metalworking. Many of the tasks and tools described can be dangerous; a working knowledge and adequate experience is expected of those following the methods described. Welding, oxygen-acetylene cutting, and the safe use of power tools can only be learned through proper instruction. Those lacking in these skills should take classes at their local community college or technical center.

In brief, the tasks that will be described in this chapter are: the cleaning, cutting, bending, and welding of reinforcement bars and the assembly of the elements into a cohesive and structurally sound armature. The primary material, three-eighths re-bar, is available at building supply stores in ten-foot lengths. Thirty feet of three-eighths re-bar and one foot of five-eighths are required for this project. Buy the straightest length. This project also requires two industrial casters with two-inch wheels, a three inches long half-inch in diameter galvanized steel water pipe, and a cane or leg tip to go on the end of the pipe.

The re-bar is usually rusty when you buy it so it is best to remove the rust with a wire brush or with a cup brush on a small side-grinder. The re-bar is most efficiently cut to length with a cut-off saw that has a fourteen-inch abrasive blade, although a reciprocating saw with a fine tooth metal cutting blade or even a hacksaw will work. An oxygen acetylene-cutting torch is useful for cutting and heating the five-eights re-bar so that it can be bent into small arcs. The length of a piece of re-bar is determined by where the steel will actually go by measuring inside the lines of the floor drawing.

Bending the re-bar is done by hand in a large vice. The jaws of the vice are left open just less than twice the width of the re-bar, and are used as a fulcrum point. When a bar is short or needs to be bent near the end, then a half-inch water pipe is slipped over the end and used as a lever. The correct arc is checked by placing a re-bar on the floor pattern and comparing it to the arcs on the pattern. Adjustments are made until they match. Sometimes it is better to cut the re-bar a few inches longer so a tight bend can be more easily made. It can then be cut to fit.

The next step is to tack-weld the re-bars together into components such as the legs and table top. Tack-welding is done to hold the pieces temporarily together, because they may have to be adjusted again. The small tack-welds keep heat from building up in one area as well as minimizing distortion and misalignment. Tack-weld re-bars with an electric arc welder using three-thirty seconds of an inch thick 6011 welding rods on the lowest setting that can maintain an electric arc. The "60" in 6011 stands for 60,000 pounds tensile strength and the "11" is for the flux coating that keeps the weld clean and is compatible with an AC (alternating current) welding machine. With a more expensive DC (direct current) welding machine use a 6010 welding rod.

The re-bars that make up the table legs are separated by spacers or short pieces of rebar. The tabletop is defined by re-bars around its perimeter, a bar dividing it into halves, and other bars radiating out that follow the projected paths of the legs. The front handle loop is constructed from a thicker re-bar for strength.

Fitting the components together requires creative methods for holding the elements in precise place for tack-welding. The tabletop armature is blocked up and shimmed level so that three temporary re-bar supports can be tacked to it. Then the blocks are removed and the legs are positioned, propped up, and clamped to the top armature for tacking.

Brackets are added to strengthen the connection of the legs to the top. Finally, temporary bracing is attached to keep all components aligned during the welding phase.

Welding takes place outdoors or in a well-ventilated area. A larger one-eighth 6011 flux coated rod is used with appropriate amperage setting for good penetration. Short welds on the accessible side of each butt joint are performed. To minimize distortion skip to different areas on the armature. This will allow the immediate area surrounding a weld to cool before welding nearby again. Turn the armature in different positions to access all the joints. Use a slag hammer to chip off the slag and burnt flux. Brush off the smoke residue with a wire brush. Attach the casters and check that all elements are still in their correct positions. Make any necessary adjustments and tack-weld. Weld the casters with the wheels covered in water to prevent them from being damaged. Cut off extra metal around the casters and clean up the entire piece with a small side-grinder. Spray the armature with bare metal primer to prevent rust.

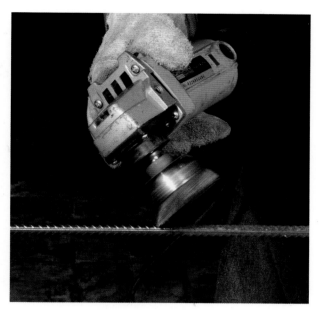

Cleaning Re-bar with a Powered Cup-Brush: A small side-grinder accessorized with a wire cup-brush is faster but also dangerous. Wear a full face shield, because the wires on the cup-brush can and do fly off. Hold the grinder at an angle so that the brush lightly touches the re-bar in its downward rotation. Move the brush lightly back and forth ten inches or so until rust is removed. Rotate the re-bar and do another section.

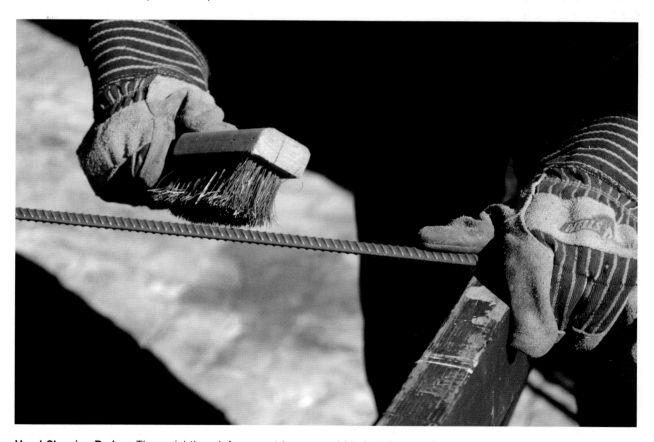

Hand Cleaning Re-bar: Three-eighths reinforcement bars are sold in building supply stores in ten foot lengths and are usually rusty and some are bent. Select only the straight ones. To clean off the rust, put a re-bar on two saw horses and wire-brush it with one hand while holding and turning it with the other hand.

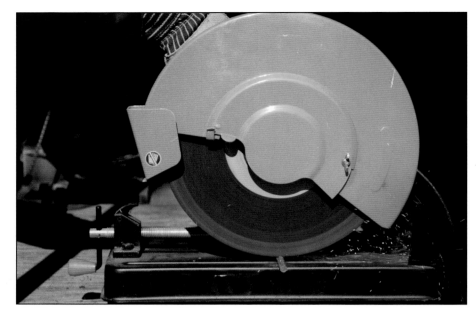

Cut-Off Saw: The cut-off saw is a useful tool for cutting re-bar. It is fast and accurate, but it is also noisy, creates sparks, and dust. Operate it outside if you can. The blade is fourteen inches in diameter and made of an abrasive material that essentially uses friction to cut through ferrous metal (steel).

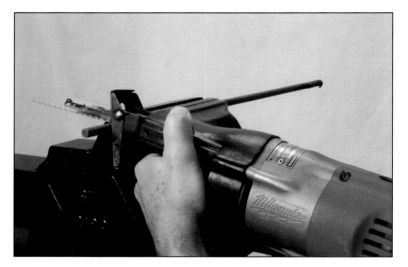

Cutting Re-bar with a Reciprocating Saw: You can use a reciprocating saw with a fine tooth metal cutting blade to cut re-bar. Secure the re-bar in a vice with the cut line close to the jaws.

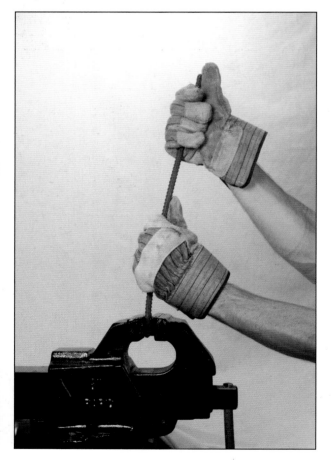

Bending Re-bar: Place a re-bar vertically in a large vice that is open just enough so that the re-bar can be moved easily between the jaws. Pull back on the re-bar with both hands until you feel it bend. Move the re-bar down an inch and repeat. When you get close to the end turn it upside down and continue bending it.

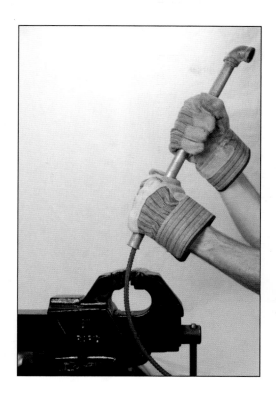

Bending Re-bar with a Pipe: To bend a re-bar to the very end that is already cut to the exact length, slip a half-inch inside diameter steel water pipe over it, to act as a lever.

Shaping Re-bar: Check the shape against the floor pattern. If the re-bar is bent too far, re-shape it by pressing the arc in the opposite direction against a hard surface.

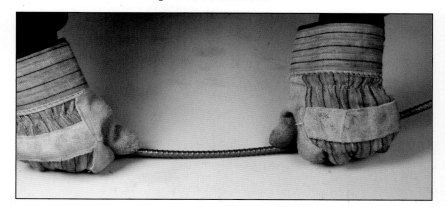

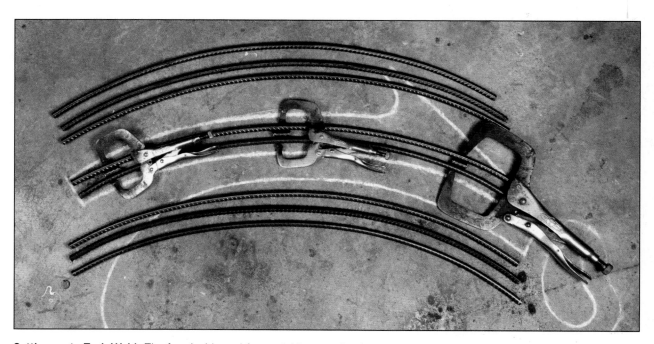

Setting up to Tack-Weld: The four inside and four outside curved re-bar pieces of the back legs are laid out and two of them are aligned and clamped to be tack-welded together.

Spacer: One-inch re-bar spacers are sandwiched between the inside and outside curved re-bar pieces of the back leg and all are lightly clamped together with welder's Vicegrip® C-clamps. Make sure the bottom ends of the re-bars, where the casters will attach, are lined up.

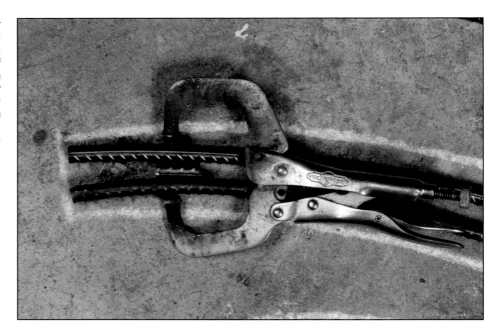

Tack-Welding: Tack-weld re-bars on the floor pattern. Strike just enough of an arc to hold the pieces of re-bar together. Briefly form a small puddle of molten metal where two re-bars contact. Ventilate the shop of smoke and fumes.

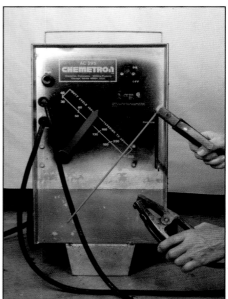

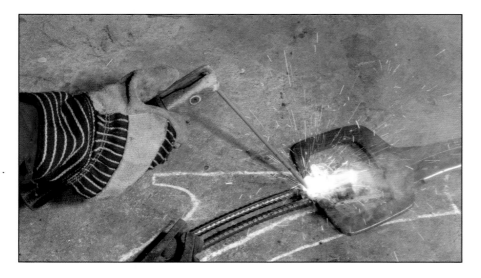

Welding Machine: The welder is set low to deliver 100 amperes alternating current for tacking. The welding rods are three-thirty-seconds of an inch flux coated mild steel rods that have a code of 6011 on them. The 60 part stands for mild steel that has a tensile strength of sixty thousand pounds per square inch. The 11 is for the type of flux coating that keeps the weld clean and free of oxygen.

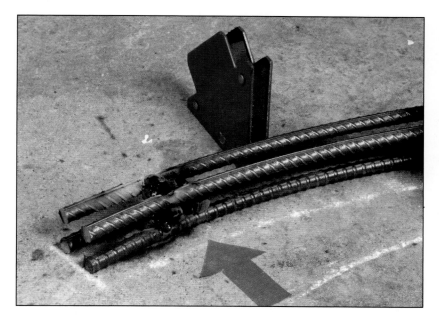

Setup: The two halves of a back leg are setup with one on top of the other and with re-bar spacers between them. The four ends that will attach to the casters are squared up flush. One of the three spacers can be seen where the blue arrow is pointing. The brown triangular object is one of several magnetic securing devices. They are the perfect tools for holding two pieces of steel together when clamping is not an option.

Parts of the Front Leg: The front leg uses only three rods because the leg must taper from a triangular cross section at the top down to a half-inch pipe with a cane tip that contacts the floor.

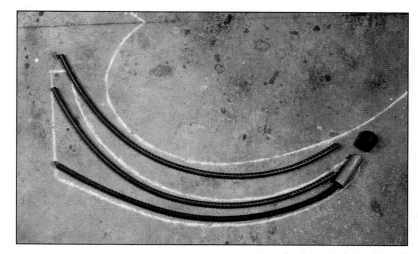

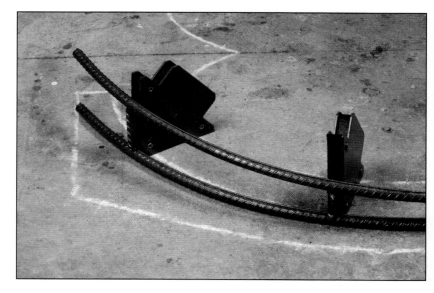

Setting up the Front Leg: The two back re-bars of the front leg are positioned one above the other on the floor pattern. They are held in place by the magnetic securing devices.

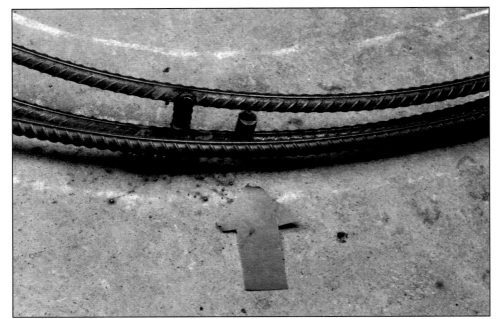

Spacers: Progressions of different length spacers are tack-welded to the back two re-bars to form one side of a tapering triangle. The blue arrow is pointing to a loose spacer that is holding the front re-bar away from the back two.

Pipe: The front re-bar of the front leg goes through a half-inch water pipe and is tacked to it. The back two re-bars connect to the back of the pipe.

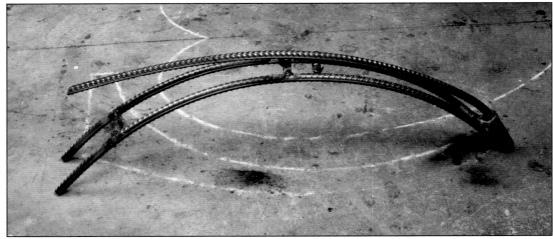

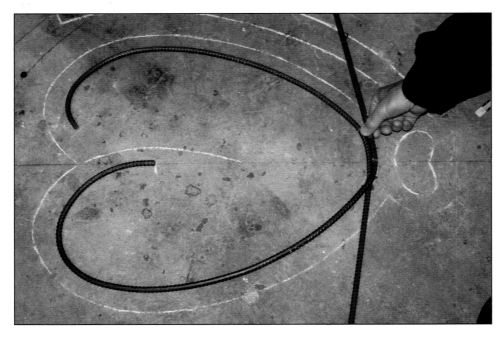

Shape and Mark the Top Re-bars: Bend two pieces of re-bar to form the contour of the top. Shape them to imaginary arcs that are one and one-quarter inch inside the floor pattern. Mark and cut them where they overlap in the front.

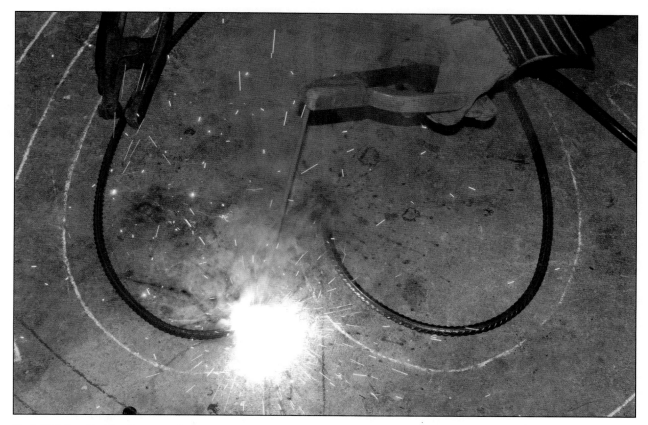

Tack-Welding the Top Contour: Tack-weld the two main contour pieces and a third short re-bar with a reverse arc that connects the back of the wings.

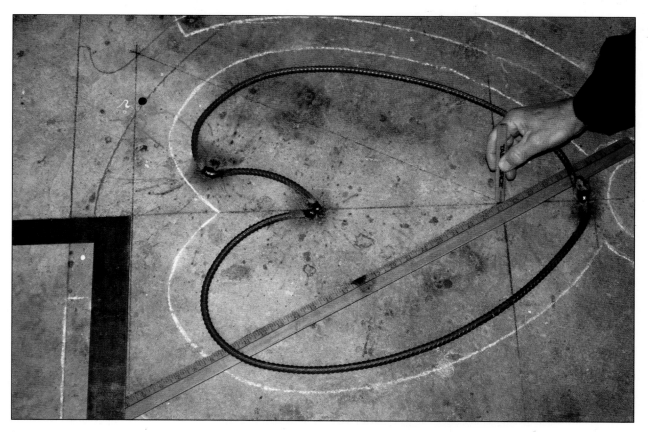

Layout Leg Positions and Support Braces: Determine where the legs will attach to the top, and mark those lines. Cut and fit the re-bars that follow those lines and also brace the top. The back legs will emerge from the center of the tabletop at the intersection of line C I and the centerline of the width. They will end on the same line, X Y as the back of the top, and be twenty-one inches apart.

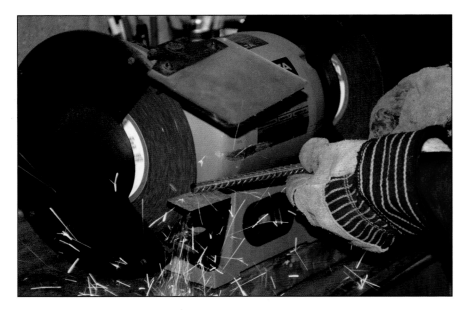

Grinding Re-bar to Fit: Sometimes when fitting re-bar in a predetermined space that has angles, there is a need to shape the square cut ends with a bench grinder.

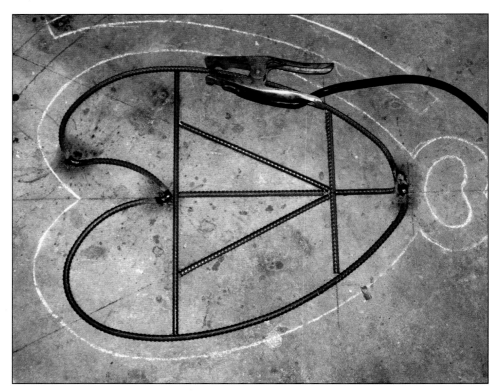

Top Armature with Bracing: The top armature with its central bracing is ready for tack-welding.

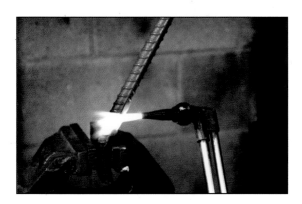

Bending Five-Eighths Re-bar with a Torch: The front handle/head is made of a five-eights re-bar. To bend it requires the use of an oxygen-acetylene torch to heat the thick re-bar until it is red hot.

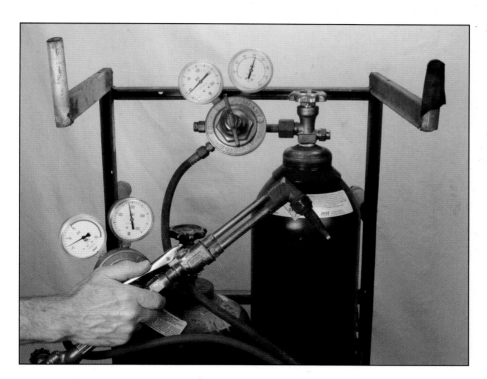

Torch, Tanks, and Regulators: Projects can be designed that do not need an oxygen-acetylene torch, but when working with thicker steel, the cutting torch is indispensable. For general use the oxygen is set at 40 pounds per square inch and the acetylene is set to 7 pounds per square inch.

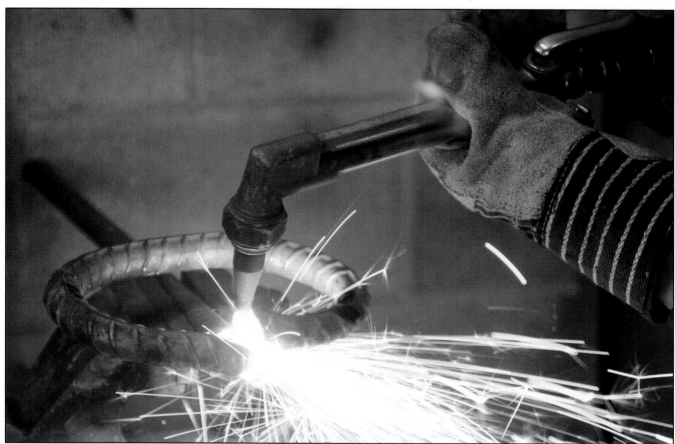

Cutting Five-Eighths Re-bar with a Torch: Bend the five-eights re-bar until it loops back over itself. Cut off the excess and press down until the ends meet.

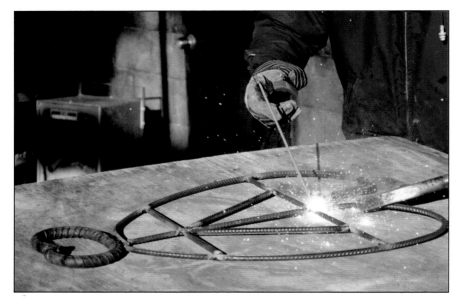

Welding Outdoors: Attach the handle and prepare to securely weld all the components. Use a larger one-eighth of an inch welding rod and turn the amperes up on the welding machine to get deep penetration. Skip around from one joint to another location, so as to minimize distortion due to heat buildup. Welding outdoors in a covered space is ideal for ventilation.

Cleaning Off Slag: Chip off the slag, burnt flux, with a slag hammer that is pointed at one end of the head and has a chisel at the other. Brush off the smoke and residue with a wire brush or with the cup brush on a small side-grinder.

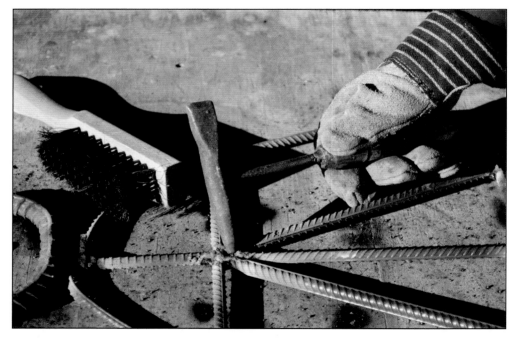

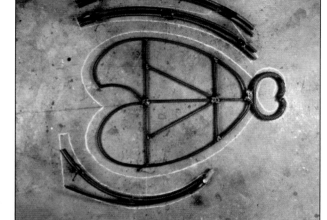

Armature Components: Place the armature components back on the floor pattern and prepare them for assembly.

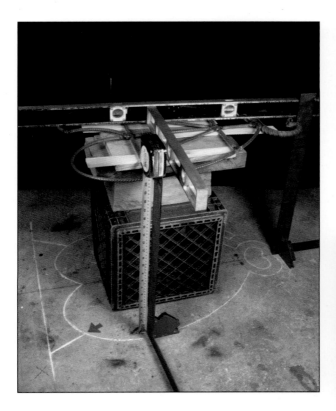

Leveling the Top: Position the top armature over the floor pattern at a height of twenty and three-quarter inches. Support it temporarily with a milk crate, blocks and boards, and level it with shims. Verify that the top is level with a four foot and a two foot level placed perpendicular to each other. Three right angle squares are confirming that the top armature is in position above the floor pattern. The tape measure is checking the height. The blue arrow is pointing to a line on the floor pattern where a back leg will go.

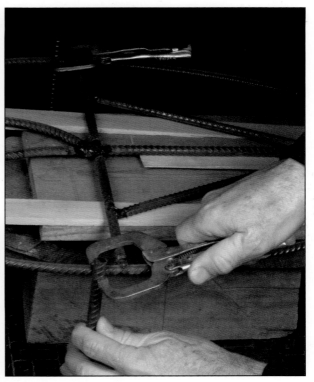

Clamping the Temporary Supports: Three temporary re-bar supports are clamped to the top armature on each side and the front with welder's C-clamps.

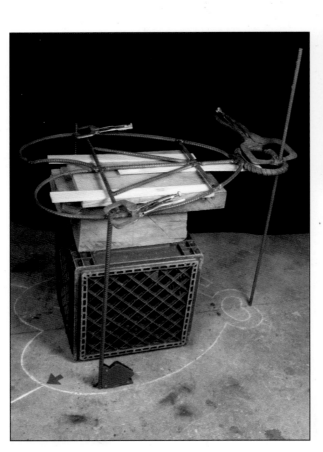

Temporary Supports: The temporary supports are tack-welded on one side only so they can be removed easily. The milk crate and blocks are then taken away, so that the top armature stands on the temporary re-bar supports.

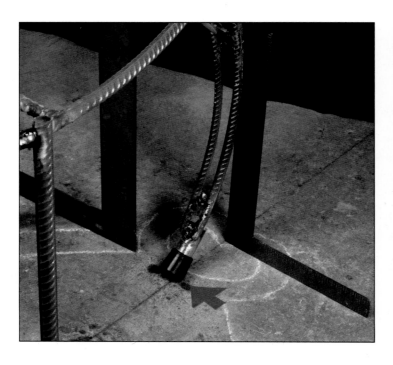

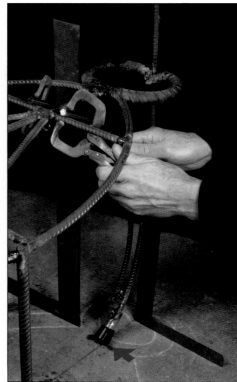

Positioning the Front Leg: Position the front leg with its cane tip in place, on the floor at the intersection of the front handle ring and the center line that is marked with the blue arrow.

Clamping: Clamp the back two re-bars of the front leg to the cross bracing of the top armature. The front re-bar is positioned under the five-eighths re-bar.

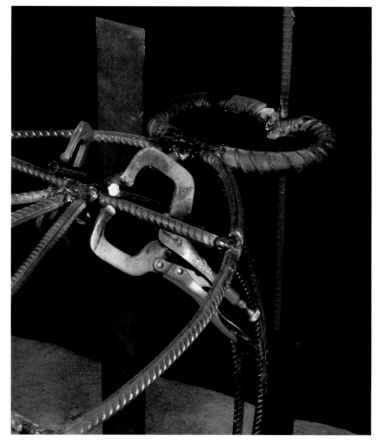

Over the Top: The back re-bars of the front leg may extend over the top surface, but they can be cut off later. Secure the front leg by tack-welding.

Back Legs: On the floor pattern, re-establish where the back legs are going to rest on the floor. The back legs will emerge from the center of tabletop at the intersection of line C I, and the longitudinal center. They will end on the same line, X Y as the back of the top, and be twenty-one inches apart.

Wood Blocks: Cut two wood blocks two and a half inches long to temporarily substitute for the casters. Attach them to the back legs with hot glue.

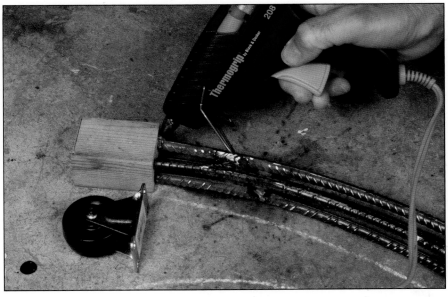

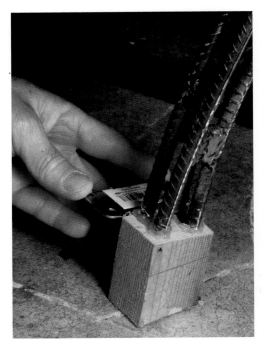

Aligning Wheels: It would be too difficult at this time to calculate the compound angles needed to align the wheels to the legs, so that they would track in a straight line. Note that the angle at the bottom of the blocks is the same as the angle where the caster will connect to the armature of the back leg.

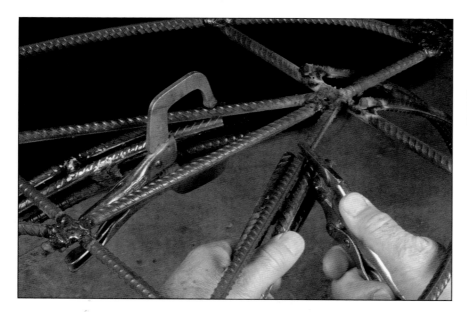

Clamping the Back Legs: The back legs are positioned and clamped to the re-bar braces on the top armature.

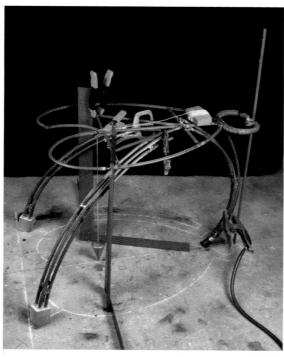

Checking Positions: The legs are kept in an upright arc with the aid of the right angle squares. All measurements and positions are checked from a plumb line dropped down from the center of the top armature to the centerline of the floor pattern. Make adjustments to the back legs as needed and tack-weld the legs to the top armature.

Back Leg Brace: Tack-weld a scrap re-bar between the back legs. Then tack-weld two more re-bars to form an "X" from the first low brace to the back of the top armature. Be sure to tack-weld re-bars only on one side, so that they can be removed with a twist.

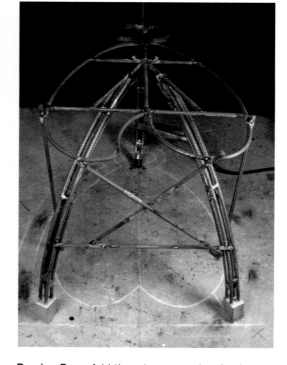

Bracing Bars: Add three temporary bracing bars (marked with blue tape) to stabilize the armature during the welding process.

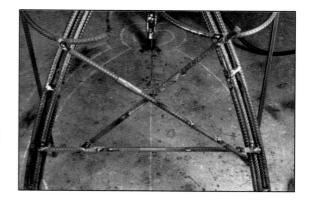

28

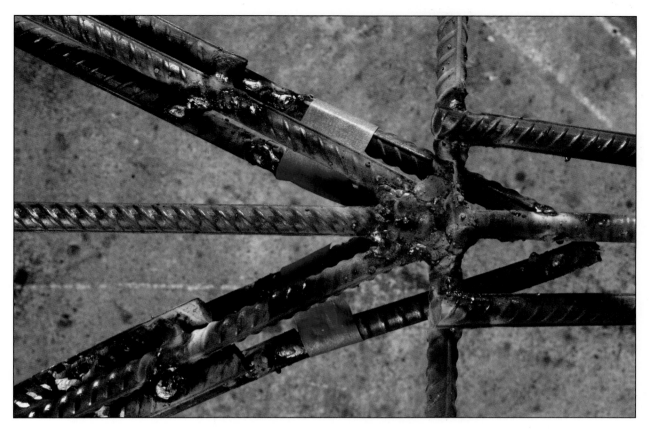

Extra Re-bars for the Back Legs: To add structural integrity, tack-weld four short re-bars to the lower set of re-bars of the back legs, and connect them to the top armature. They are marked with blue tape in the picture.

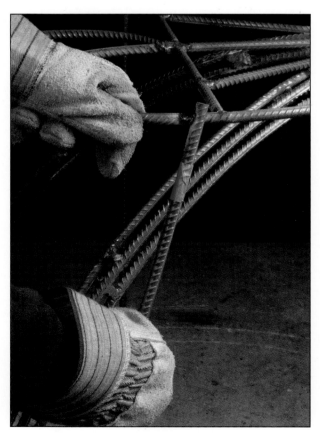

Breaking Off Temporary Supports: Now that the permanent legs are braced and tacked, detach the three temporary supports. Pull the temporary re-bars toward their tacked side and they will break free.

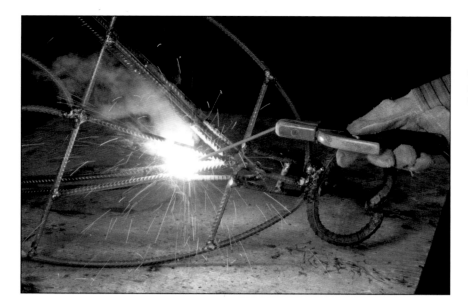

Welding the Armature: Weld the armature elements securely in a well ventilated area or outside.

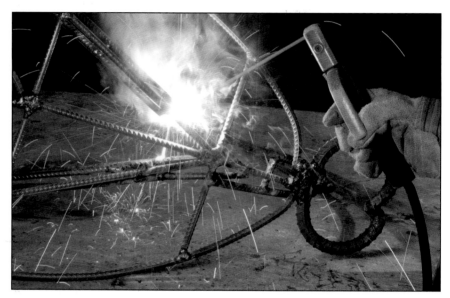

Alternating the Welding: Skip from one tacked joint on one leg to another connection point on another leg to minimize the chance of excessive heat warping the armature.

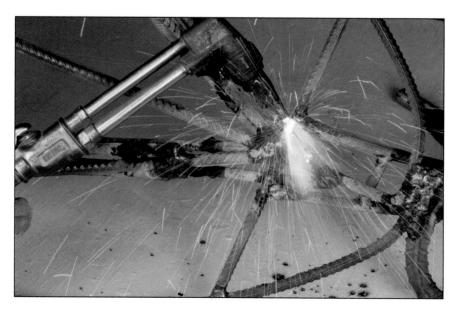

Torch Cutting: Use a cutting torch to remove the extended re-bars from the front leg that protrudes above the tabletop surface.

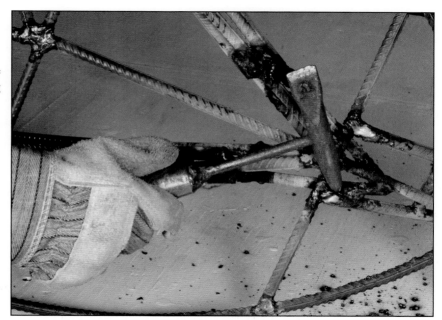

Slag Hammer: Chip the slag off with the pointed side of the slag hammer.

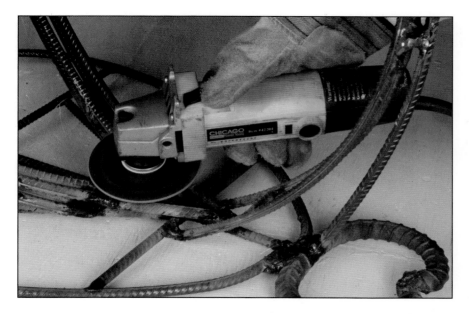

Grinding: Clean up the welds with a small side-grinder.

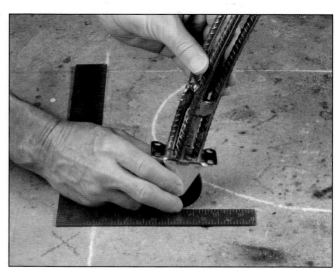

Aligning the Back Wheels: Align the back wheels so that they track in a straight line with the forward movement of the table.

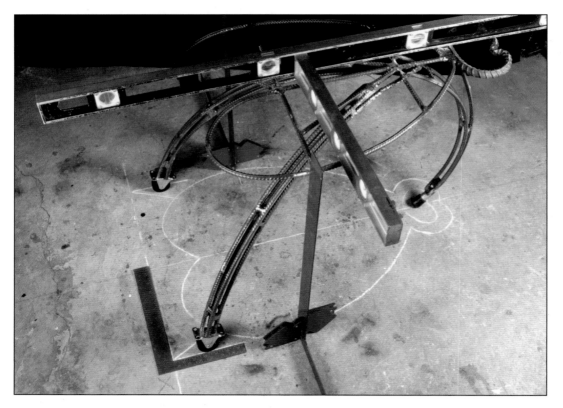

Leveling: Check for level from front to back and side to side. Make adjustments as necessary and tack-weld the armature with a three-thirty-seconds welding rod on the lowest possible setting.

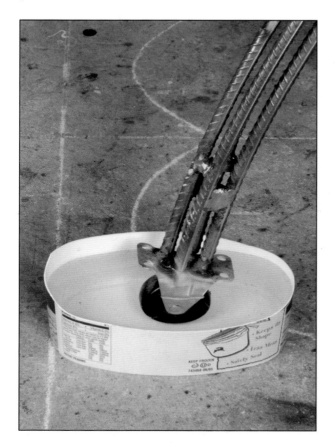

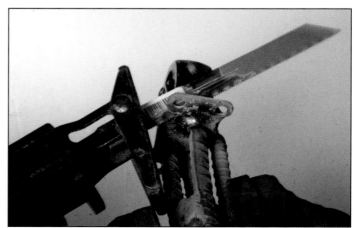

Removing Extra Hardware Material: Place a back leg in a vice close to the caster, and support the armature. Cut off the unnecessary part of the caster's mounting plate, so that only the section welded to the back leg re-bars is left. Use a reciprocating saw with a fine tooth metal cutting blade. Position the blade away from the wheel to keep from damaging it.

Water Cans for Welding the Casters: The intense heat of welding may damage the wheels. Place the wheels in containers filled with enough water to cover them to help dissipate the heat. Complete the welding of the caster to the re-bar legs.

32

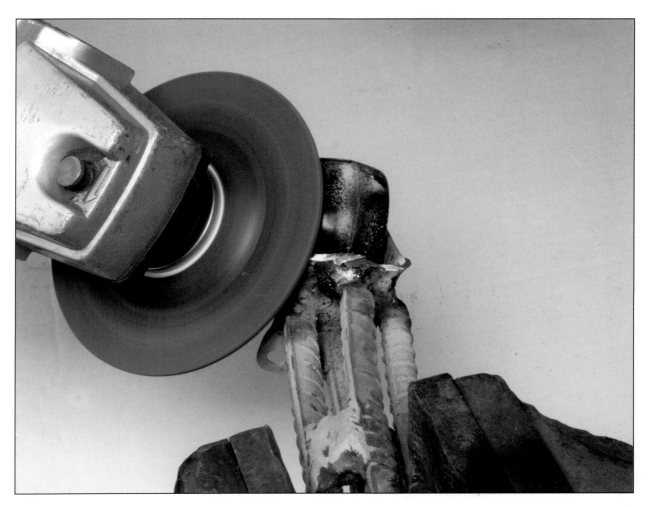

Grinding the Caster Base: Use the small side-grinder to clean up the connection between the casters and the legs. Remove as much metal as possible from the wheel yoke below the attachment plate. Concrete will cover the top of the caster's yoke, so that the legs appear to be organic and animal-like.

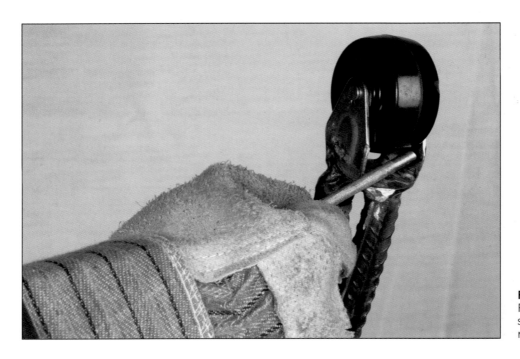

Filing Caster Base: Remove the burs and sharp edges with a small round file.

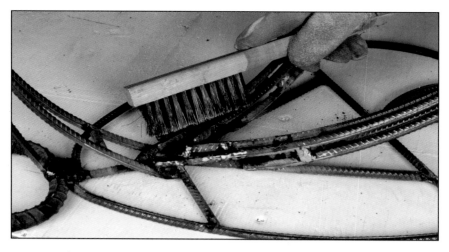

Wire Brushing: Wire brush by hand one final time to remove smoke and loose slag.

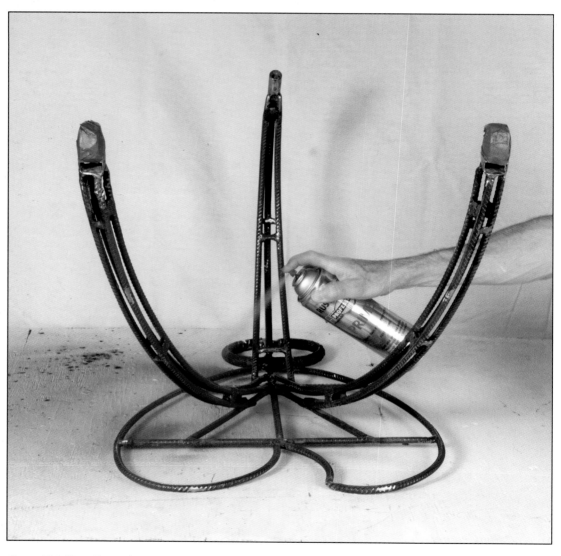

Spray Painting: Cover the wheels with painter's tape and remove the cane tip.
Spray the armature with a good quality bare metal primer.

CHAPTER THREE
WIREWORK: BLOOD

Wirework is essential to the success of the Direct Concrete Technique. Wirework is wrapping the armature in layers of chicken wire and hardware cloth. The mesh and proximity of galvanized wires gives concrete something to adhere to, especially on vertical elements and the underside of horizontal elements. The combination of a steel armature and woven wires just beneath the surface of concrete provide tensile strength, complementing the compressive strength of concrete. Wirework enables the creative development of ideas into cutting-edge designs that make concrete look thin, light, and sensuous.

Chicken wire and hardware cloth are available in the garden section of building supply stores. Chicken wire is packaged in three- or four-foot wide rolls from ten to twenty-five feet long. Hardware cloth is sold in two- and three-foot wide rolls in shorter lengths. To preserve the shelf life they are coated with oil that must be cleaned off. It is easier to remove the oil by scrubbing the whole roll with a brush and detergent before it is cut.

Strips of hexagonal wire or chicken wire can be stretched and manipulated to cling to curve elements, such as table legs. Woven wire or hardware cloth is rigid and works best on large flat areas like tabletops. It comes in several sizes that are determined by the open squares between the woven wires. For this project the half-inch and the quarter-inch variety will be employed. The smaller, quarter-inch hardware cloth is effectively used in areas that will be subject to heavy use or have only a thin layer of special concrete. For most areas several layers of wirework are needed to close open spaces between the chicken wires and the larger woven wires.

Wirework frequently is secured to the armature by its own free wire ends. These are the wires that are left unattached after the wire is cut from the roll. The free ends of the chicken wire can be over an inch long and are wrapped around re-bars and twisted around itself or other wire. The free ends of hardware cloth are short, but can often be hooked on the layer of wirework beneath it. For extra security, two-inch lengths of eighteen-gage galvanized wires are used as twist-ties to hold wirework to the armature.

To prepare the wirework for concrete, all sharp wire ends are turned into the armature so that they don't snag on hands or gloves. Loose fitting layers are tightened to the armature by twisting wires in an "S" shape with needle-nose pliers.

Other tools needed are wire cutters and sheet metal shears, for cutting hardware cloth. Safety glasses are a must to protect eyes from flying snipped wires. Never use pliers to pull wires toward your face—wires break unexpectedly. If you can, work in leather gloves. However, it is difficult to perform many of the tasks required with gloves. Wirework demands a great deal of concentration and dexterity. The probability of lacerations is high, and the wounds from wires are ragged and painful—thus the subtitle: *Blood*.

Cleaning Chicken Wire: Chicken wire is sold with oil on it to prevent rust. Oil is a releasing agent for concrete and must be removed. It is easier to wash the whole roll with a brush and detergent before it is cut.

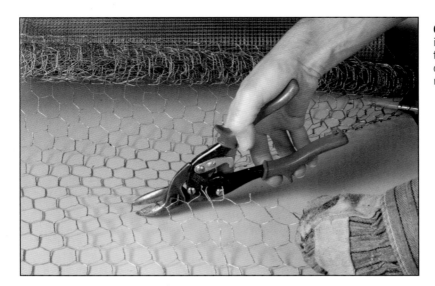

Cutting Chicken Wire: Cut six- to eight-inch strips of chicken wire across a three foot wide roll. Clamp the chicken wire down to relax it, because it will otherwise naturally curl back into a roll.

Applying Wirework: Wrap the chicken wire strips around the back legs in a spiral so that at least half of the width overlaps in each rotation. Begin where two elements are joined and work towards the open end of the leg.

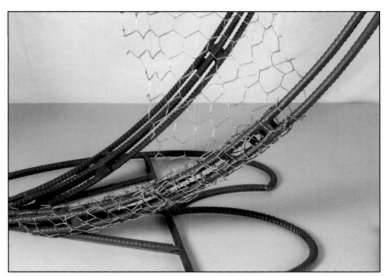

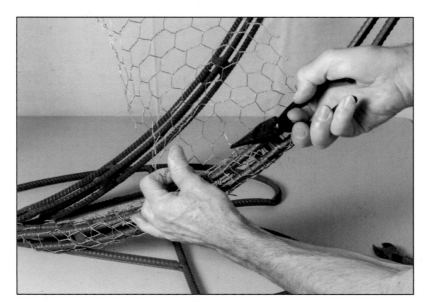

Wrapping Wirework: With your fingers and needle nose pliers pull the chicken wire tight, so that it is as close to the re-bars as possible.

Attaching Wirework: Using the needle nose pliers, work the free ends of wire back into the underlying layer. Press in and tighten all wires that are sticking up or loose.

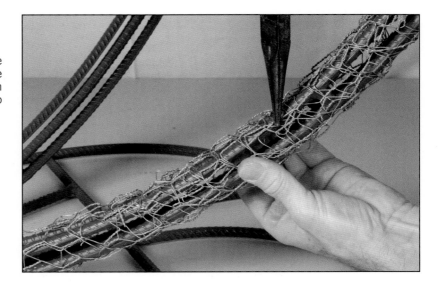

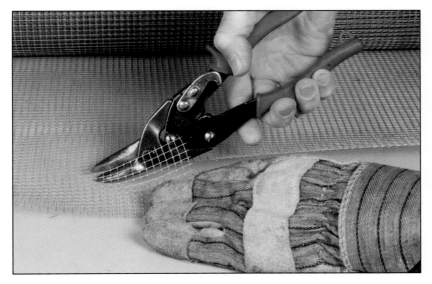

Cutting Hardware Cloth: Hardware cloth comes in three sizes; one-eighth, one-quarter, and half-inch woven squares. For this project the quarter and half-inch variety will be employed. It is easier to cut hardware cloth with sheet metal shears than wire cutters.

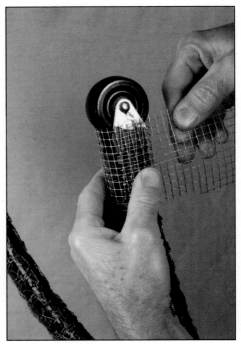

Wrapping Hardware Cloth Around the Casters: The quarter-inch hardware cloth is wrapped around the caster up to the wheel so that most of the metal yoke is concealed when the concrete is applied.

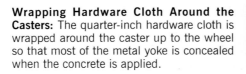

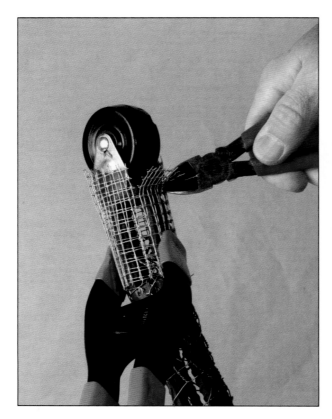

Trimming Hardware Cloth: The hardware cloth is held in place with a spring clamp. Wire cutters are used to trim an opening for the wheels. Cut along the side to one square above the caster base.

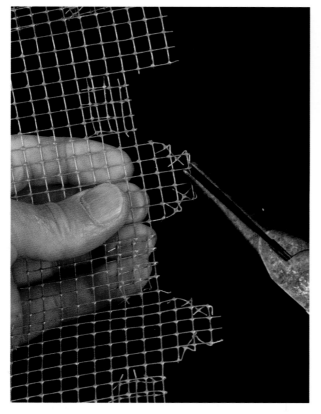

Folding Hardware Cloth: Take the hardware cloth off the leg. Fold the trimmed openings to the inside of the metal cloth.

Shaping Hardware Cloth: Shape the area of the hardware cloth that corresponds with the "V" part of the caster yoke. Bend the sharp free ends of the wires in, so that they won't catch on fingers or gloves.

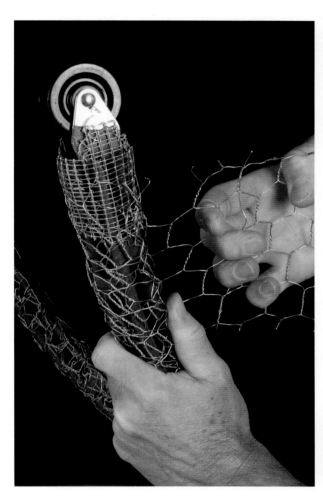

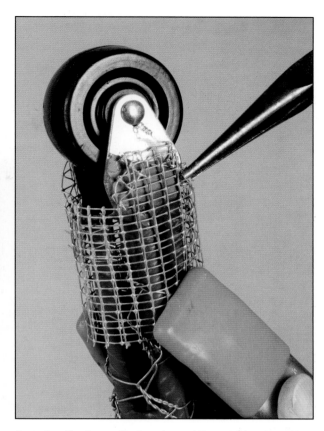

Securing Hardware Cloth to Legs: Wrap the hardware cloth back around the legs and casters so that the opening for the wheels and the cover for the yoke align on the casters. Hold it in place with a spring clamp. Work the wire ends of the top wrap into the layer under it, so that they hook together.

Wrapping Legs in More Chicken Wire: Cut a four-inch by three-foot strip of chicken wire. Wrap it around the legs and over the hardware cloth to completely encase the leg again.

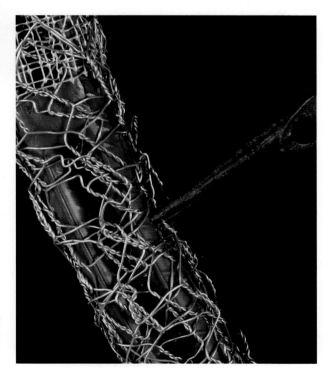

Tying Wires with Needle Nose Pliers: Work all the ends of wires back into the underlying layer of wirework. Tighten all loose wires in the hexes by twisting to make a little "Z" or "S" with the needle nose pliers.

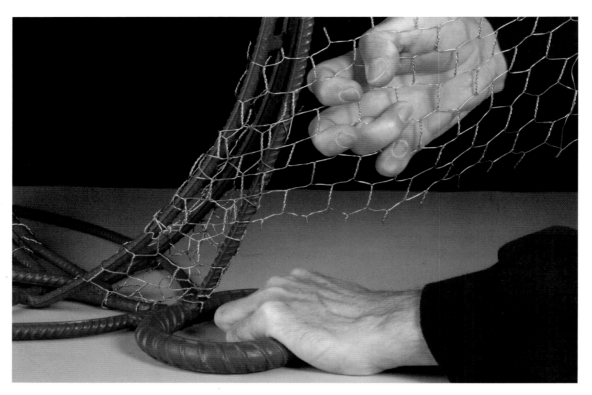

Wrapping the Front Leg in Chicken Wire: Cut a five-inch by three-foot strip of chicken wire and wrap the front leg from where it connects with the top armature to the cane tip end.

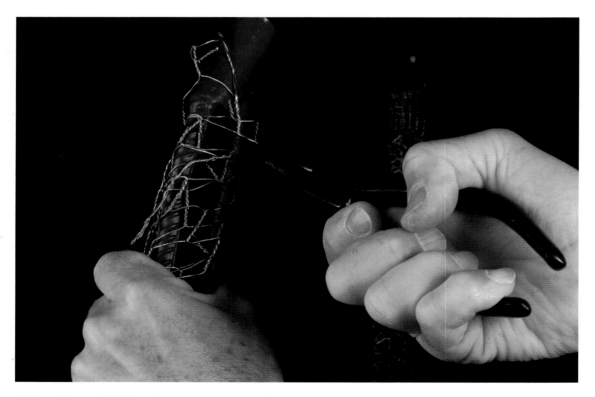

Tighten Wires with Pliers: Insert the long nose of the needle nose pliers into a hex opening in the chicken wire and lever it against the armature to stretch the chicken wire as close to the leg re-bar as possible.

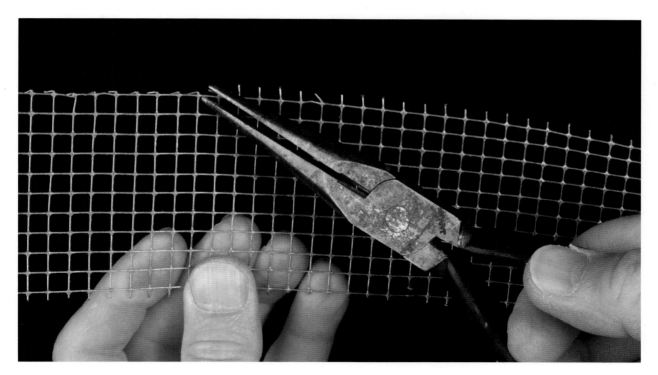

Preparing Hardware Cloth: Cut a strip of hardware cloth about two and a half-inches by eight-inches to go around the cane tip and lower front leg. Bend the ends of the cut wires along the length as shown.

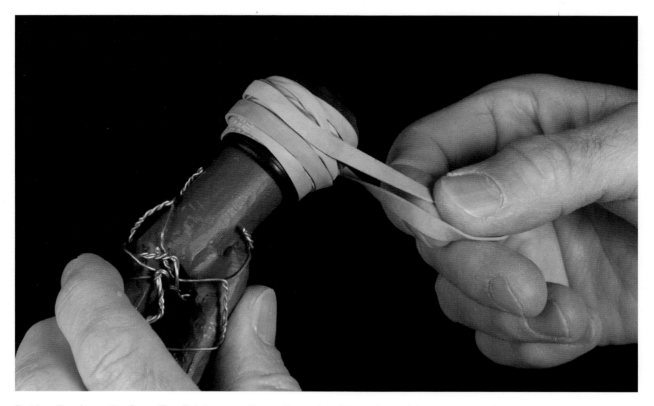

Rubber Bands on the Cane Tip: Put the cane tip on the end and wrap four rubber bands around it. The rubber bands are a temporary spacer so that the hardware cloth will not be drawn too tightly to the cane tip.

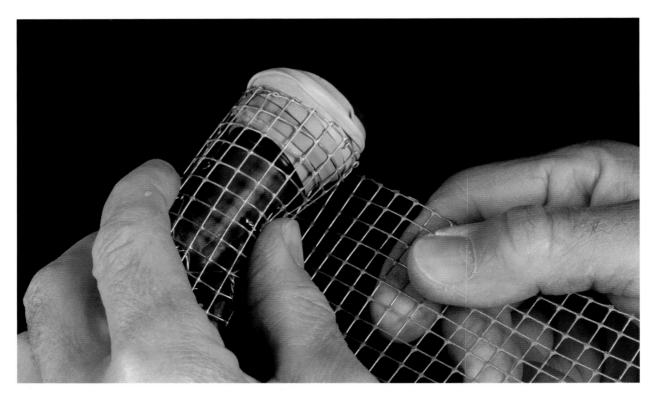

Wrapping the Hardware Cloth Around the Cane Tip: Wrap the strip of hardware cloth around the cane tip with the prepared edge on top of the rubber bands, about a half-inch from the very end.

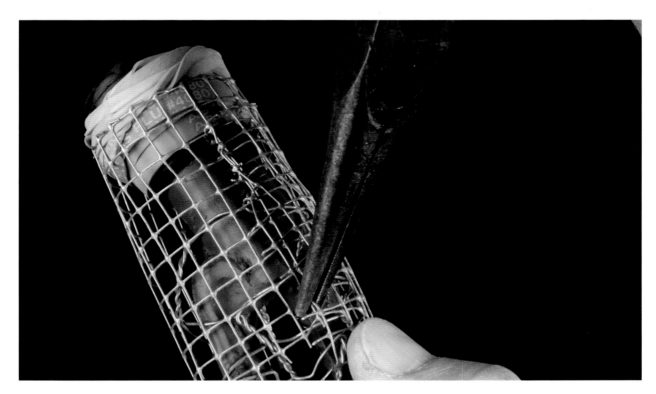

Securing Hardware Cloth: Secure the hardware cloth by working the free wire ends back into the underlying matrix.

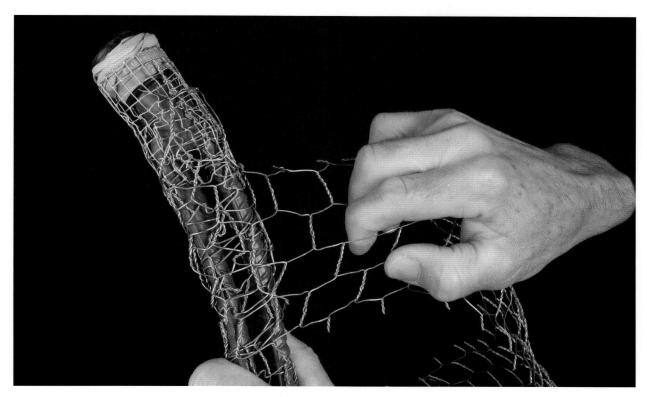

More Chicken Wire: Cut a strip of chicken wire, four hexes wide by three feet. Wrap it over the hardware cloth and around the front leg towards the tabletop.

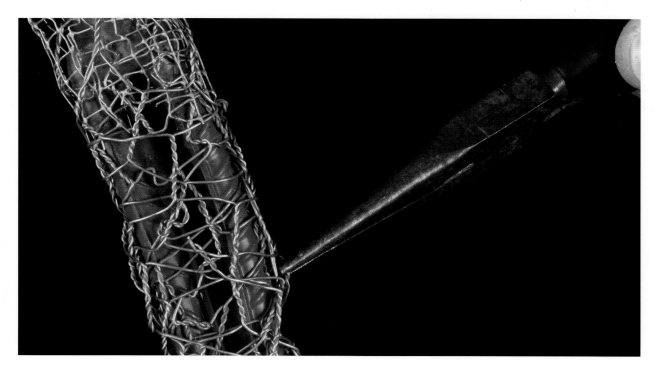

Securing: Secure the chicken wire by twisting the free wire ends of the hexes to the underlying wire.

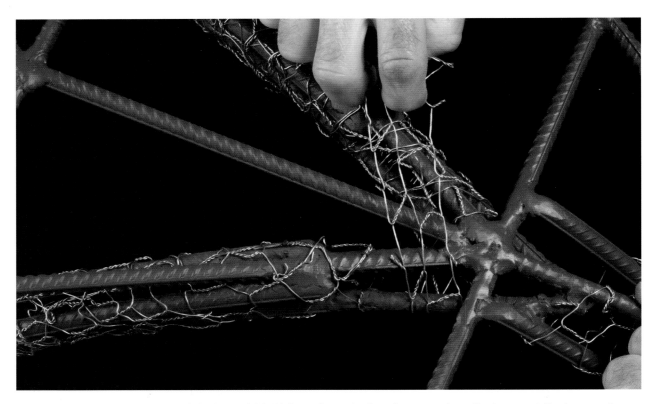

Wirework on the Junction Area of the Legs: Add chicken wire to the junction area where the legs meet the top armature.

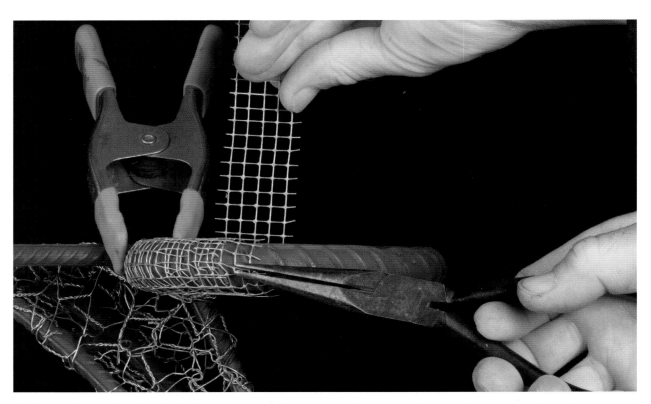

Hardware Cloth on the Handle: Cut a narrow strip of hardware cloth and wrap it around the front handle. In the picture a spring clamp is holding the first turn of the hardware cloth in place. The pliers are kinking a cell of the hardware cloth on the leading side to take up slack on the curve, so that the next turn of wire will lie flat on top of it.

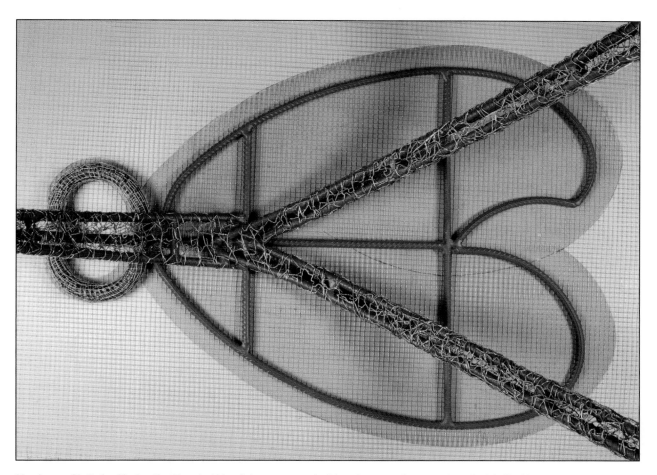

Hardware Cloth for Under the Top: In this picture you are looking down on the armature that is itself upside down. It lies on top of one quarter-inch hardware cloth and the top paper pattern. The hardware cloth will be cut out larger than the pattern and then used on the underside of the top armature.

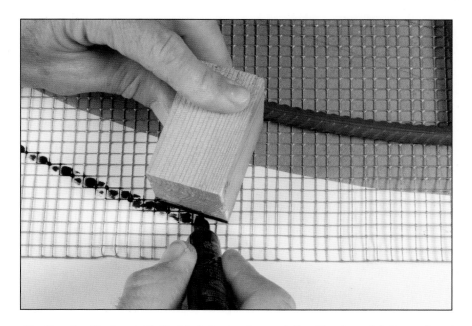

Marking the Hardware Cloth: Mark the hardware cloth with a large felt tip marker at least an inch larger than the pattern. A two-inch block of wood that was previously used as a temporary caster spacer, works well when aligned against the armature to keep the proper spacing.

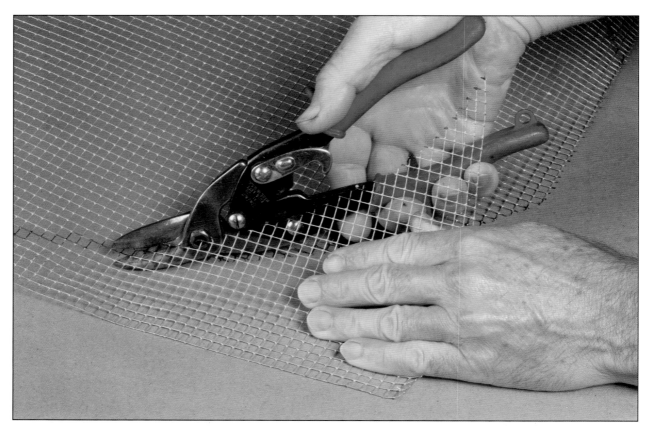

Cutting Hardware Cloth: The quarter-inch hardware cloth is easer to cut with sheet metal shears.

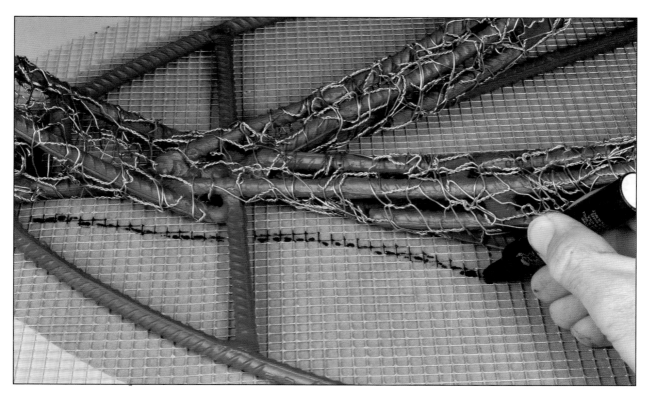

Marking the Center Waste: Stack and align the pattern, the cut piece of hardware cloth, and the upside down armature. Mark the hardware cloth where the legs intersect with the top armature element. This part will be cut out so that the hardware cloth will fit on the underside of the top armature.

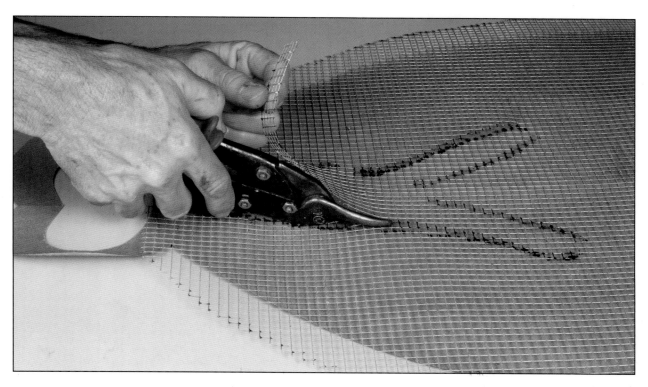

Cutting Out Waste: Cut out the waste hardware cloth that is shaped like a "Y".

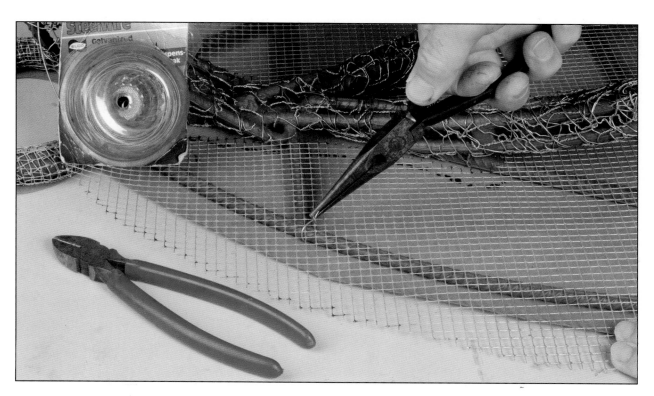

Attaching Hardware Cloth: Maneuver the hardware cloth around the base of the legs and position it above the underside of the top armature with an equal amount overhanging on all sides. Secure it to the armature with eighteen-gage galvanized steel wire.

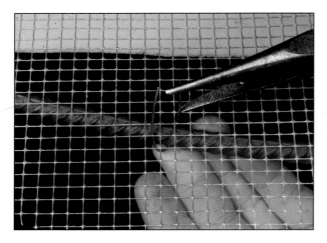

Wire Ties: Cut a piece of eighteen-gage galvanized steel wire two and a half-inches long. Bend it to form a "U", and push it up from under the re-bar and through the hardware cloth so that one or two squares above the re-bar are caught.

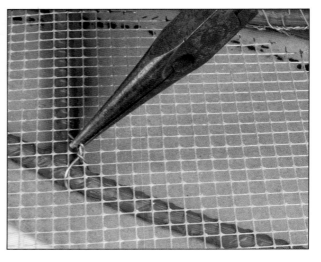

Twisting Wire: Twist the wire ends around a few times until it is snug against the re-bar. Take care not to break the wires. Cut off the ends above the twist and tuck the twisted ends below the hardware cloth.

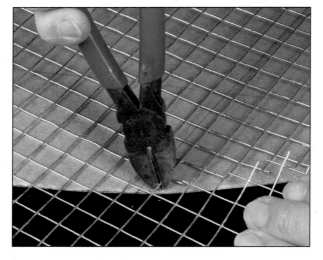

Cutting the Half-inch Hardware Cloth: Use the half-inch hardware cloth for the top of the table. Clamp the top pattern to the hardware cloth with spring clamps. Cut one quarter-inch inside the pattern to allow for the coverage of concrete. Use wire cutters for accuracy.

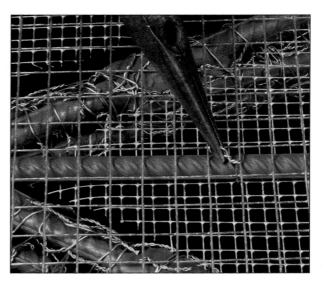

Attaching Half-inch Hardware Cloth: Turn the armature back upright on its legs and position the half-inch hardware cloth on top. Secure the hardware cloth to the top armature in several places using eighteen-gage galvanized steel wires.

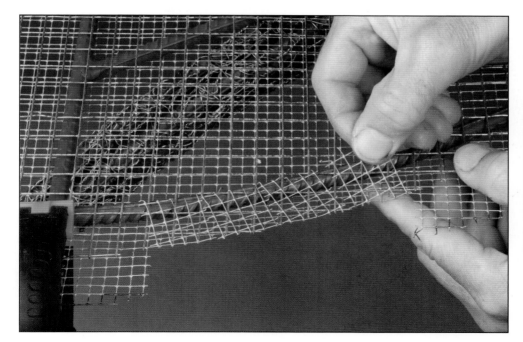

Making the Edge: Cut the quarter-inch hardware cloth every four or five squares from the outside to the edge line formed by the half-inch hardware cloth. Push each tab up to meet the tabletop and fold them back over the half-inch hardware cloth. This process will make the finished edge thinner and the table will look lighter.

Crimping: Squeeze the edge of the top with pliers to make a continuous rim. Work the free ends of the quarter-inch hardware cloth back into the half-inch hardware cloth. Secure both pieces of hardware cloth with the steel wire-ties so that both pieces lie flat in parallel planes separated only by re-bars.

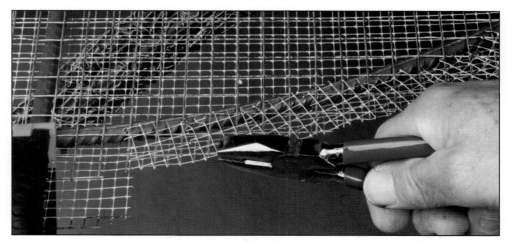

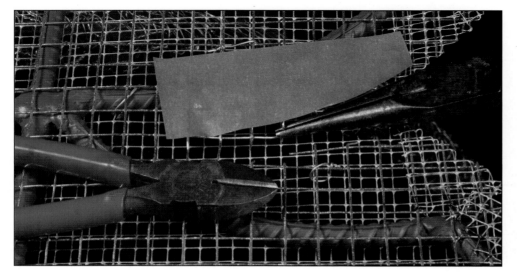

Wings: In order to make the top look like an insect at rest with its wings folded back, one wing must appear to be on top of the other. This is done by cutting the top half-inch hardware cloth three inches in an arc that is continuous with the back of a wing. The blue tape marks this cut line. The needle nose pliers are turning the free wire ends down. On the opposite side, the lower wing is defined by pressing the top wire cloth to meet the quarter-inch cloth below.

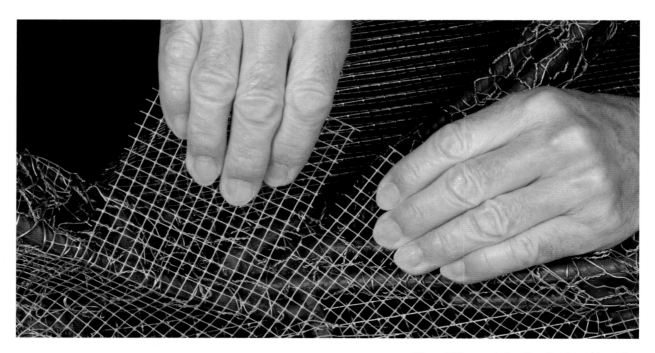

More Wirework in the Center: Turn the armature over and add more wirework to the central junction where the three legs are connected to the top. The quarter-inch hardware cloth matches the under top wire and so is easier to work in. Add more chicken wire where needed on the legs until there is no space larger than three-eighths of an inch without wire anywhere on the piece.

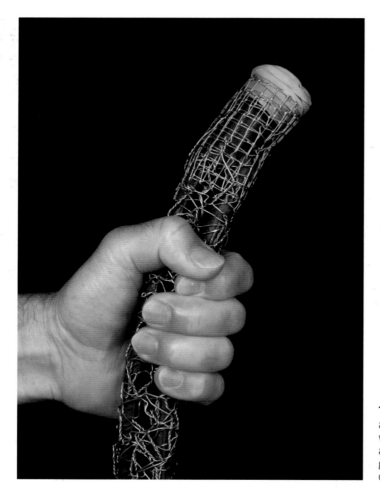

Touch Test: Check that all free ends of wire are turned in to the armature, by touching the wirework. It is better to be lightly pricked now and correct the problem, than to have your gloves torn and hands cut when applying the concrete forcefully.

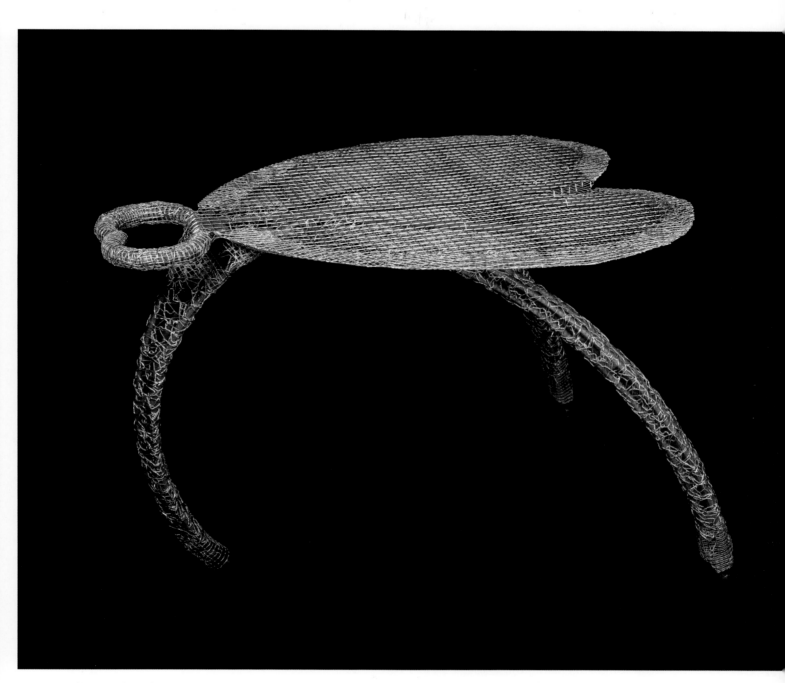

Wirework Complete: The wirework is complete and the form is examined one last time before it is set in concrete.

CHAPTER FOUR
CONCRETE: EARTH

This chapter is about how the elements of *Earth*, sand and Portland cement, are fashioned into fantastic objects in a structured but playful way. Volume and mass are built up in a cycle of adding concrete, curing, and removal of excess. The method utilized is the Direct Concrete Technique—a process of applying wet concrete by hand to a wire-covered armature and sculpting it.

First the delicate parts of the artwork are re-inforced with Quikrete® Anchoring Cement before the regular concrete mix is applied. Anchoring cement is a high strength compound for setting bolts in concrete slabs. It sets in minutes, expands slightly, and is stronger than regular concrete. Mix only a few tablespoons at a time with water and apply it with a palette knife to areas reinforced with quarter-inch hardware cloth. The perimeter of the tabletop is done with the table upside down on a flat surface over a plastic film. The ends of the legs around the casters and cane tip are also covered with anchoring cement at this time. After twenty-four hours, the anchoring cement is shaped with a wood rasp to reduce the high spots. The tabletop edge is sculpted to the contour arcs of the pattern. More anchoring cement is applied to the top edge after the *Fly Table* is turned over. The tapered top parameter edge of anchoring cement is not only stronger than concrete, but also acts as a dam when the regular concrete is applied in the center of the *Fly Table*.

The next stage is to mix and apply concrete that is technically a mortar mix of sand, cement, and water. Sand is sifted through a window screen to remove pea size gravel. Sand is then measured by volume and combined with cement in a ratio of three to one. An estimate is made and enough dry ingredients are mixed to complete the whole piece. Next a small portion, four or five large trowels full, no more than can be used in an hour, of the dry mix is separated into a clean bucket. Water is slowly added and the mixture is turned over and stirred with a small mason's trowel. Stop adding water when all the dry parts are dampened and the mixture begins to hold together. Check that there is not too much water by dropping the bucket from about three inches onto the floor repeatedly until the mixture settles. If any water comes to the surface then absorb it with paper towels.

To apply the wet concrete, put on tight-fitting neoprene gloves, pick up a handful of concrete, and force it through the wire and re-bars. Put more on from the other side and press until all air spaces between the re-bars and wires are filled with concrete. Pat the concrete repeatedly to make it settle. It will ooze out of lower areas as it settles. Keep recycling what sags, adding more concrete, forcing it in, and patting it. Use a trowel and artist palette knife to shape or add more, and a paintbrush to smooth out the concrete.

The fresh concrete is kept damp by misting it with water and covering it with plastic to create a humid environment. When the concrete has set up, it can then be wrapped in wet rags and covered in plastic for curing. In the first three days concrete is soft enough to be shaped by carving and rasping. The high spots can be sanded by hand or power tools.

Tables are cast upside down on a flat surface with plastic film acting as a release. Designs drawn on the plastic with hot glue will transfer to the tabletop as linear depressions. Marble chips can also be incorporated into the top by placing them on the plastic film under the armature.

Proper personal safety equipment must be used at all times: A dust-mask when working with the dry ingredients or sanding, safety glasses when the mixture is wet, neoprene gloves when handling the concrete, and ear plugs and face shield when power sanding.

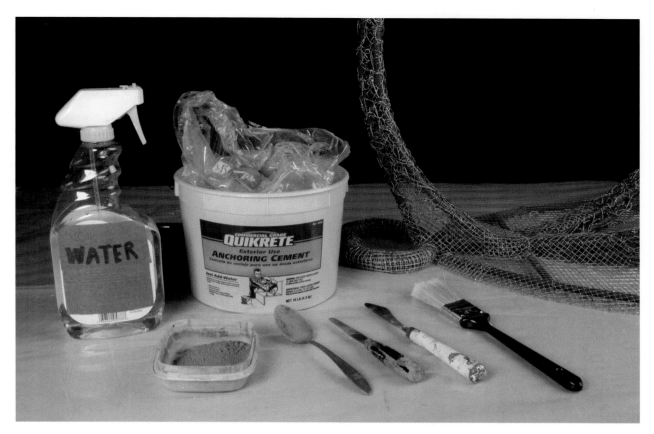

Anchoring Cement and Tools: The delicate parts of the artwork are reinforced with Quikrete®
Anchoring Cement before the regular concrete mix is applied. Anchoring cement is a high strength
compound for setting bolts in concrete slabs. The tools needed for mixing are a small plastic dish, dry
spoon, artist palette knife, paintbrush, and a spray bottle of water.

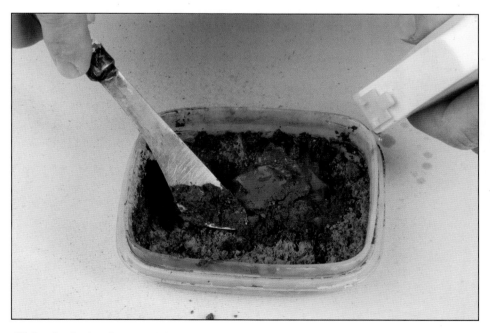

Mixing Anchoring Cement: Mix three heaping tablespoons of anchoring cement with water
in a small low-sided plastic container. Add a little water at a time from a spray bottle. Mix
until a stiff creamy paste is achieved, then apply it quickly.

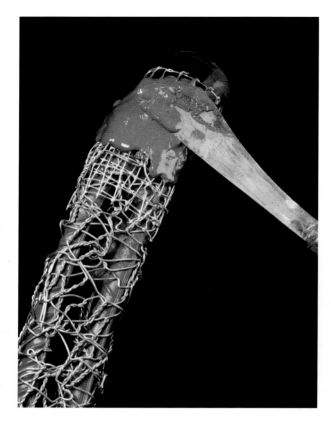

Spreading Anchoring Cement: Use a wide palette knife to spread the anchoring cement through the hardware cloth on the end of the front leg. Note the rubber bands have been removed so that the space between the cane tip and hardware cloth is filled.

Smoothing with a Brush: In a few minutes, when the anchoring cement begins to set, smooth out irregularities with a damp brush.

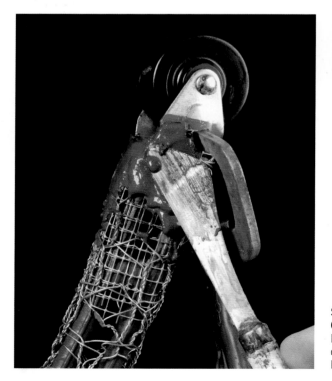

Spreading Anchoring Cement on the Back Casters: The anchoring cement is spread on the hardware cloth ends of the back legs as it was on the front, but it is a more complex process because it goes around the yoke of the casters.

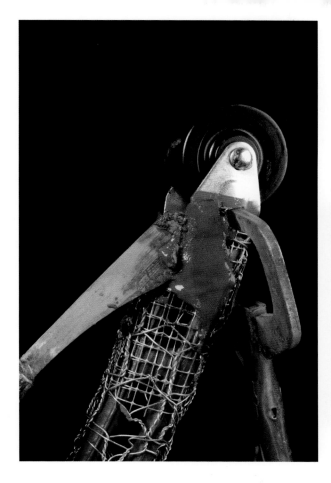

Anchoring Cement on the Back Casters: The hardware cloth on the caster is being held in place with a small welding clamp. Smooth the anchoring cement with a brush. Clean the wheels and exposed caster yokes with a paper towel when done.

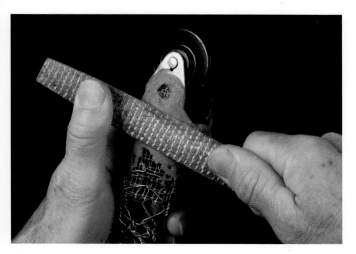

Rasping off Anchoring Cement: The next day, when the anchoring cement has cured, remove the clamps on the back legs. Use a rasp to reduce the high spots and shape the end of the legs. A dull wood rasp is easer to control and does not take too much material off at a time.

Plastelene: The next area to be reinforced is the top edge. Tape the top pattern to a flat working surface and cover it with six mil plastic film. Create a spacer for the area where one wing overlaps another with plastelene, oil-based sculpting clay. Form it into a tapered wedge and place it over the pattern. Then lay another piece of plastic film over the plastelene. Turn the armature upside down, and place it on top of the pattern with the cut-out and shaped part of the wings aligned with the plastelene spacer.

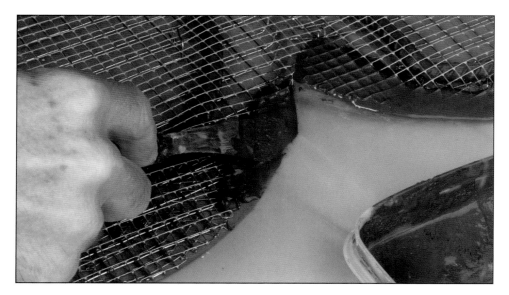

Spreading Anchoring Cement on Back Edge: Apply anchoring cement around the top edge of the *Fly Table* where the quarter-inch hardware cloth is folded over the half-inch hardware cloth. Press the anchoring cement into the wire and maintain a smooth edge by working the palette knife up from the plastic film and along the edge. Later, when the concrete is poured in the center, the anchoring cement will act as a dam. The back edge is pictured, where the plastelene spacer is creating a void.

Spreading Anchoring Cement on the Handle: Apply anchoring cement to the front handle, because it will receive a lot of wear, and it needs to be thinly coated so it does not feel bulky. Keep working the palette knife from the plastic film up so that the anchoring cement does not sag.

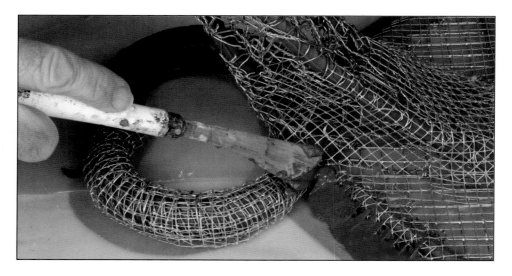

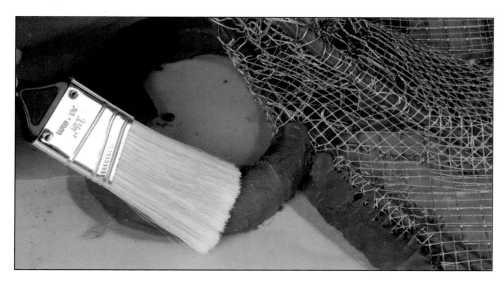

Smoothing Anchoring Cement: Smooth the anchoring cement with a damp brush.

Rasping Anchoring Cement on the Handle: The anchoring cement has cured overnight. The armature is turned over and the excessive cement around the handle is removed and shaped with a rasp.

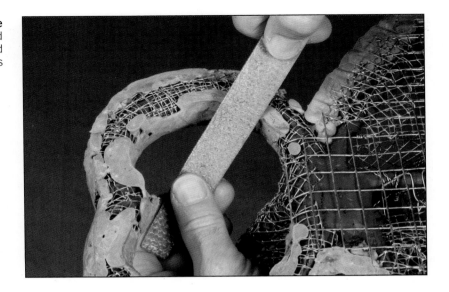

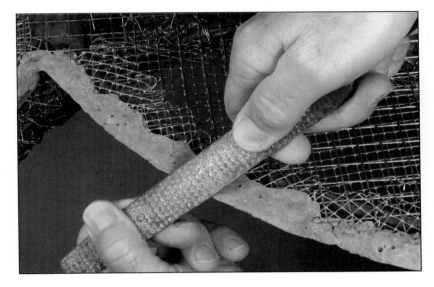

Rasping the Edge: The edge around the top is shaped into a smooth arc with a rasp. Care is taken not to rasp wires along the edge, but if some are exposed they will be covered in later applications.

Sanding the Back Edge: Sand the slick top of the edge that was in contact with the plastic to give it enough roughness that the next layer of anchoring cement will adhere to it.

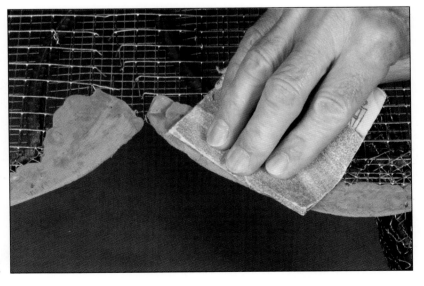

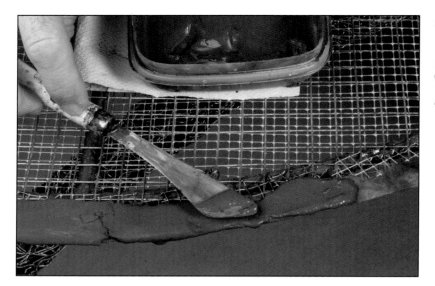

Spreading Anchoring Cement on Top Edge: Dampen the top edge of the piece with the spray bottle. Use a wide palette knife to apply and spread anchoring cement on the top of the edge. Build it up about one-eighth of an inch and flatten it smooth.

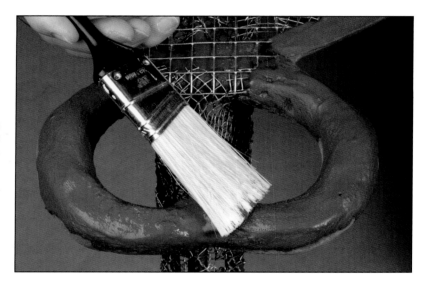

Smoothing Anchoring Cement on the Handle: Apply anchoring cement to the top handle and smooth it with a damp brush.

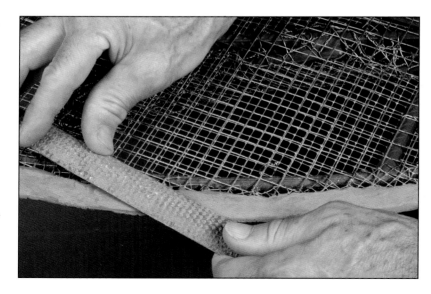

Rasping the Top Edge: The next day use a dull rasp to flatten the top surface of the anchoring cement around the edge to one-eighth of an inch higher than the half-inch hardware cloth. Check for any anchoring cement that may have oozed over the edge.

Marking the Top Pattern: Tape the top pattern to a flat sturdy working surface. Simulate the veins in an insect's wings by drawing freehand with a pencil and then trace the lines with a felt tip marker.

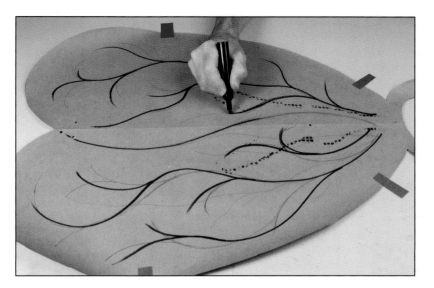

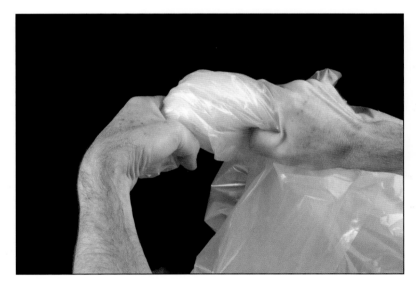

Twisting Plastic: Cut a sheet of six-mil plastic film large enough to cover the working surface where the concrete application will be done. Twist the plastic like you would wring a wet towel, to negate crease marks and to add texture to the *Fly Table* top.

Setting the Clay Spacer: Secure the plastic film to the working surface with duct tape leaving the pattern underneath. Reposition the plastelene spacer on the plastic film over its place on the pattern.

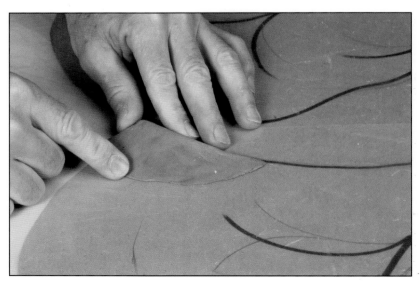

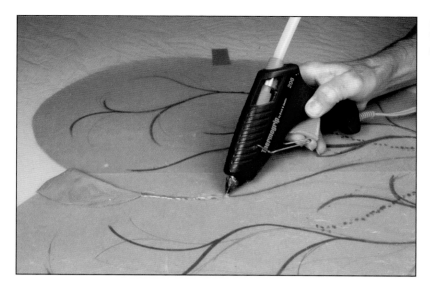

Hot Glue: Run a thick line of hot glue from the tapered end of the plastelene spacer to simulate the edge of the top wing.

Detail of Hot Glue: Run a line of hot glue over the marked veins.

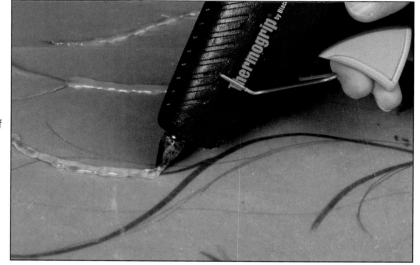

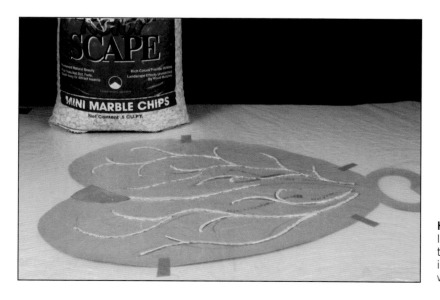

Hot Glue on Pattern: The hot glue will leave little trenches on the surface of the *Fly Table*. The trenches will be filled in with a finer mixture of cement and will have a slightly different color.

Adding Marble Chips: To make the surface more interesting and give it a terrazzo-like effect, add mini marble chips. Half-cubic-foot bags are available in the gardening section of building supply stores.

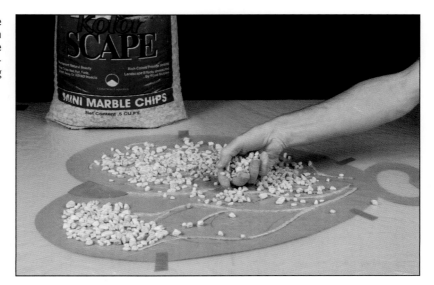

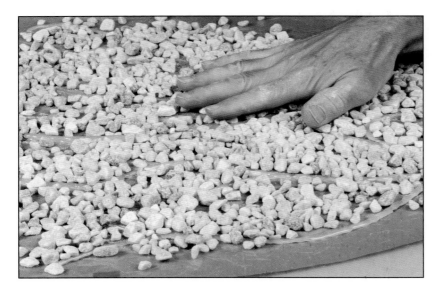

Flattening the Marble Chips: Flatten the marble chips with your hand so that they form one even layer. Keep the chips away from the edge where they would interfere with rebar and anchoring cement.

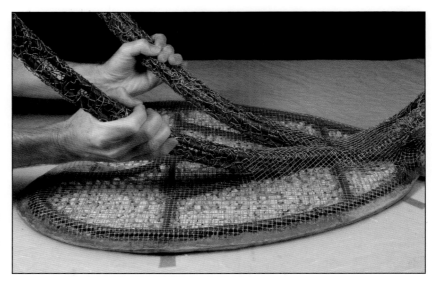

Positioning the Armature: Turn the armature over and position it on the pattern. Rotate it back and forth so that the marble chips work their way into the half-inch squares of the hardware cloth.

Measuring Sand: Measure dry sand into a large coffee can. For this project, three coffee cans of sand and one and a third cans of cement is sufficient. Always make more dry mix than needed, so that it is all consistent.

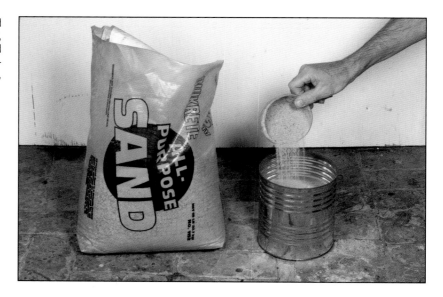

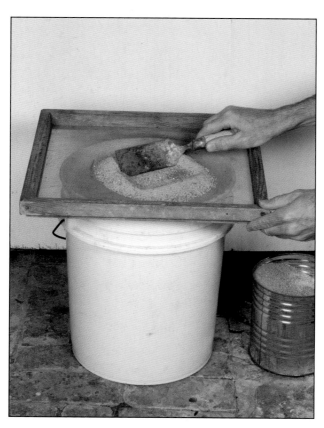

Sifting Sand: Sand can be bought in many grades; pre-sifted, all purpose, and by the shovelful contaminated with leaves and sticks. Sift all sand through window screen to remove pea size gravel and organic matter. If it is damp, spread it out and dry it in the sun before sifting.

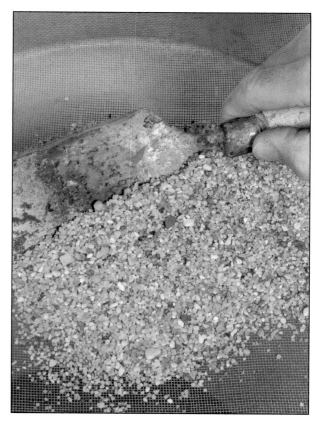

Pea Gravel: Use a small rectangular trowel to aid in sifting the sand through a window screen into a five gallon bucket. Remove the pea size gravel.

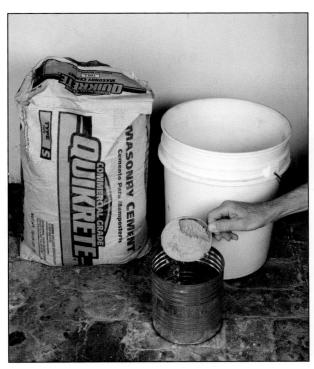

Measuring Cement: Measure one and one-third coffee cans of type N mortar mix. Type I and II Portland cement can also be used. It is important that the cement be dry. Store the sack of cement in a sealed plastic garbage bag.

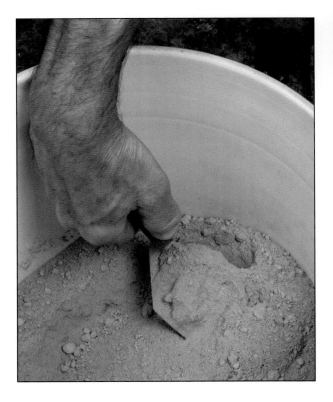

Adding Cement to Sand: It is best to alternate layers of sand and cement filling the five-gallon mixing bucket so that the mixing is more complete. If the cement has hardened into lumps, because of improper storage, than it is necessary to sift the cement or discard it.

Dry Mixing: Dry mix the sand and cement with a small triangular trowel. Mix by scooping deep, bringing the mixture up from the bottom, and turning it over. With a large project, dry mixing is easer and more effective with a powered cement mixer.

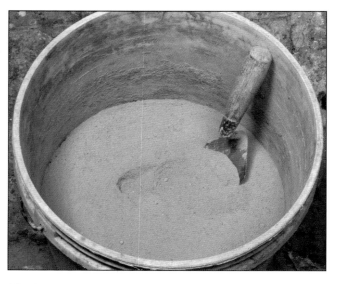

Pouring Bucket to Bucket: To thoroughly mix, pour into another dry bucket, stir with the trowel, and pour back. This should be done outdoors while wearing a dust mask.

Mixed: When the dry mix is thoroughly mixed it has the light gray color of cement. Pour one half of the dry mix into a three-gallon bucket for wet mixing. Wet mix only as much concrete as can be applied to the armature in an hour.

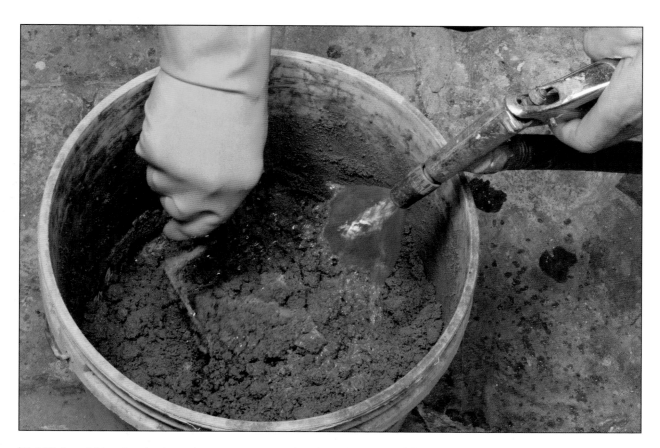

Wet Mixing: Add water slowly, and wear a neoprene glove to protect your mixing hand from the wet concrete. Stir like you did with the dry mix, from the bottom up, exposing the dry to the wet, and adding a little more water as needed.

Mixing: Use a small rectangular trowel to scrape the sides and bottom of the bucket for any stray dry mix. You will feel more resistance with the rectangular trowel and the stiff mix. Do not add any more water.

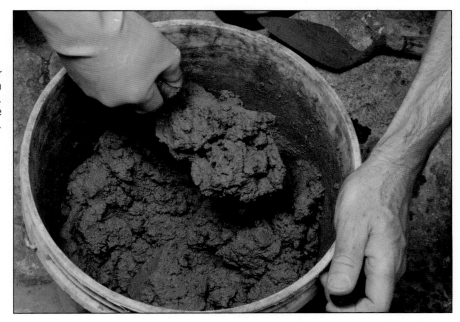

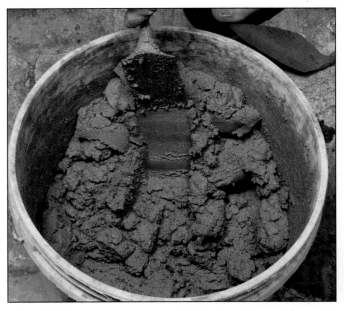

Stiff Mix: Pull some concrete to the side of the bucket. It will be stiff and stay in place without slumping.

Bouncing the Bucket: To check for excess wetness, lift the bucket a few inches off the floor and drop it. Drop or bounce it repeatedly ten to twenty times until the surface of the concrete is flat. Air bubbles may come to the surface but no water should accumulate. If there is any water, use paper towels to absorb it.

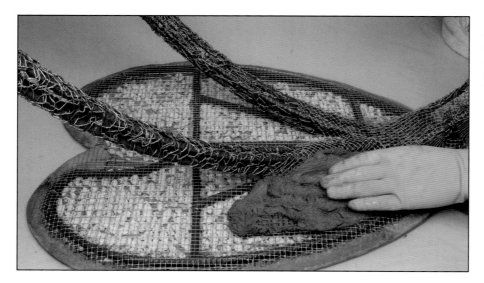

Applying Concrete: Apply concrete to the underside of the *Fly Table* with a trowel. Spread the concrete around and force it through the wirework with your hands.

Forcing Concrete through the Wirework: Push the concrete between the re-bars of the legs and where they connect to the top.

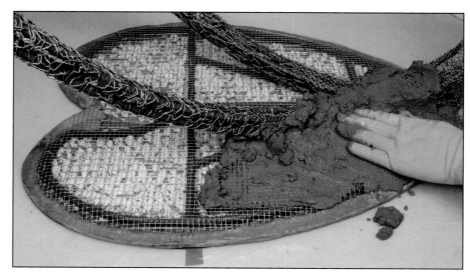

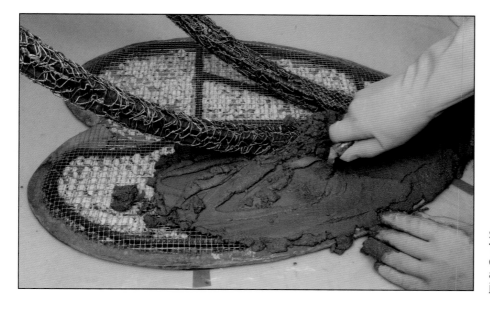

Smoothing Concrete with a Trowel: Spread and level the concrete with a trowel to create a consistent thickness that just covers the hardware cloth.

Patting Out the Bubbles: Slap or pat vigorously the concrete with the palm of your hand. This is important; it brings air bubbles to the surface and settles the concrete.

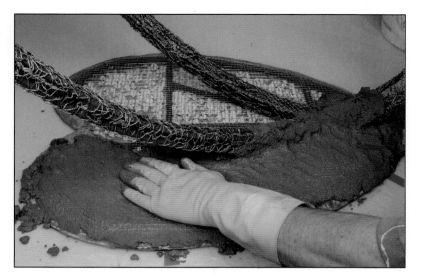

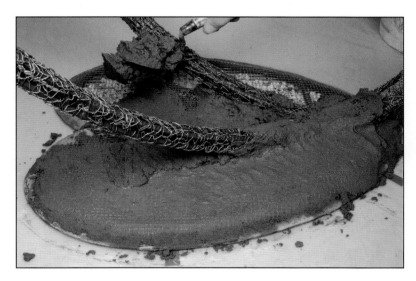

More Concrete: Keep applying concrete to all the flat areas.

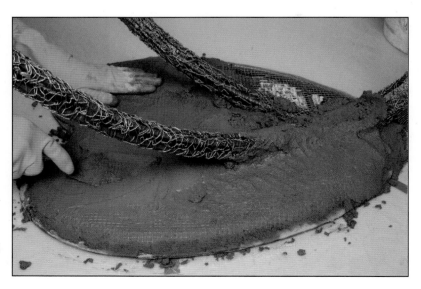

Patting and Smoothing: Continue patting and prodding the concrete with your hands, and leveling and smoothing with a trowel.

Paper Towels: As moisture comes to the surface, soak it up with paper towels.

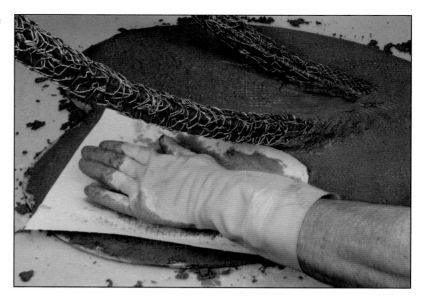

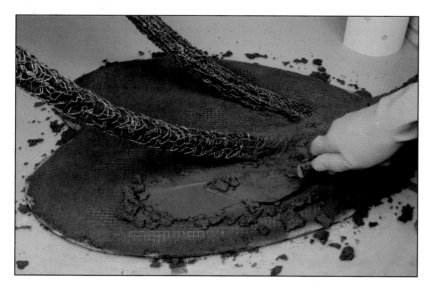

Troweling on More Concrete: Trowel on another thin layer of concrete so that the wirework is covered.

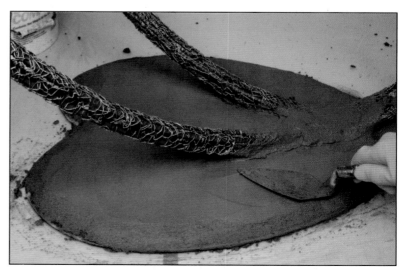

Smoothing: Make a smooth surface of a consistent thickness by floating the trowel. Use a lighter touch to let the trowel glide over the surface.

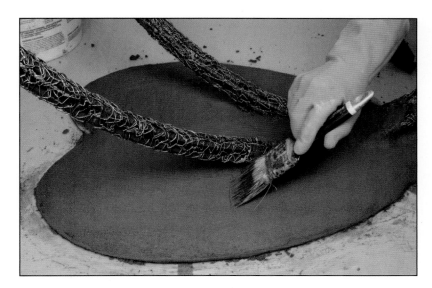

Brushing: Use a two-inch paintbrush to shape the transition area from the flat underside of the top to the edge, and around the areas where the legs join the top.

 Applying Concrete to Front Leg: Apply the concrete to the base of the front leg and push it into the central space between the re-bars.

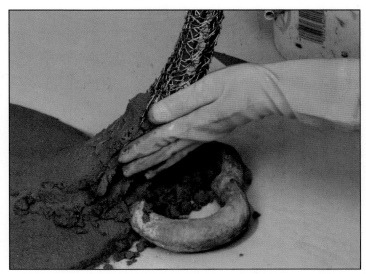

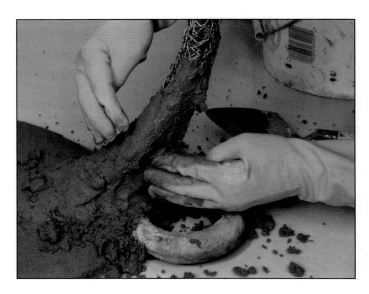

Poking the Concrete: Force the concrete into the leg cavity with your finger tips.

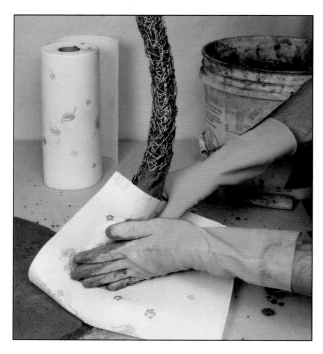

Paper Towels on Front Leg: Remove the excess moisture with paper towels to create a stiff base to build up from.

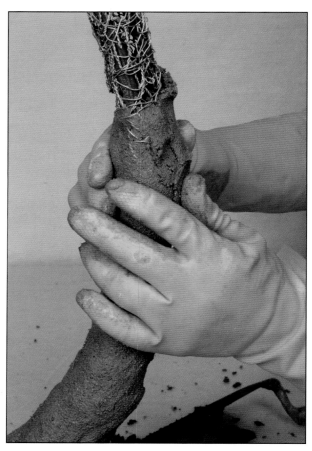

Sculpting by Hand: The Direct Concrete Technique is most challenging when working on vertical elements.

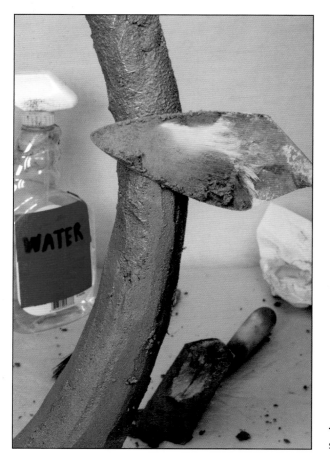

Troweling: Periodically trowel the vertical surface to maintain consistency.

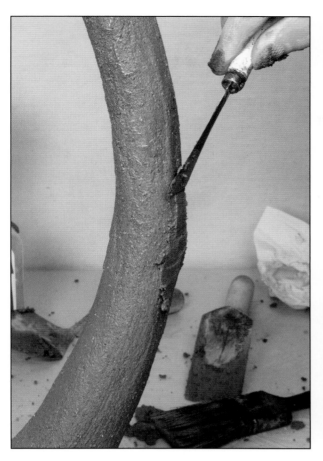

Palette Knife: The palette knife is useful for filling in small low areas.

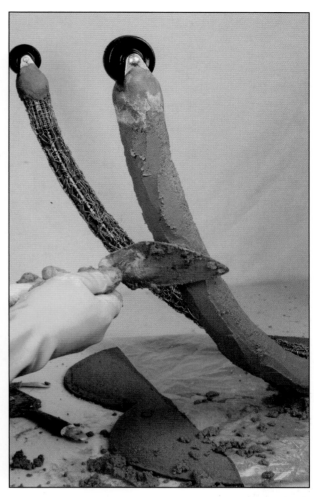

Back Legs: Use all the techniques previously mentioned to make the concrete hang upside down on the back legs.

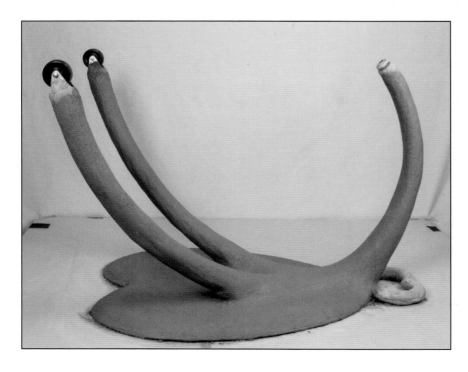

First Coat: Ninety percent of the concrete is applied in the initial phase.

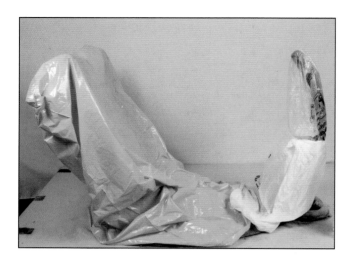

Covering: Cover the piece with plastic bags and let it begin to set for three to four hours.

Spraying: Uncover the piece every four hours to check if it is drying out. Keep it wet by misting it with water. A paint spraying system using a compressor makes the finest mist, but a spray bottle will work. Keep the concrete damp but do not let the water pool in flat spots. Often it is necessary to spray in the middle of the night to keep to the schedule.

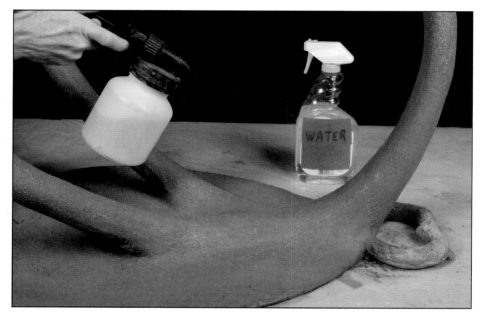

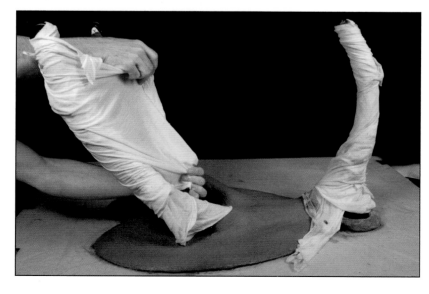

Damp Rags: After twelve hours concrete has set up well enough that the surface is not harmed by light contact.

Wrapping: Dampen rags by soaking them and wring them out. Wrap the rags closely against the legs and cover the rest of the piece completely.

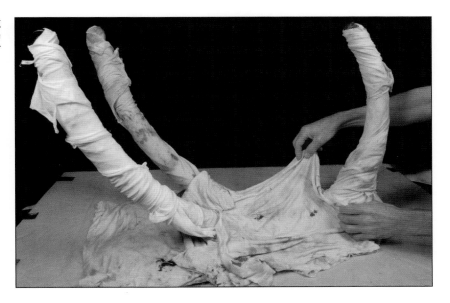

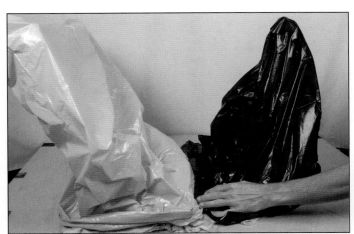

Plastic Bags: Cover the *Fly Table* with large plastic bags and let it cure for twenty-four hours.

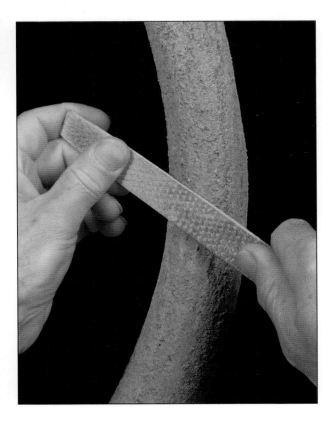

Rasping Legs: After thirty-six hours of curing, uncover the table and let it dry out for thirty minutes. The concrete is still soft and easy to shape with a rasp. Lightly glide the rasp over the legs to reduce the high spots.

Rasping Back: Scrape the flat parts with the rasp to make them level. Brush away loose debris, mist with water, wrap in rags and plastic as pictured earlier, and let it cure for at least four days.

Turning Over and Releasing: When it is well cured, in this case six days, the *Fly Table* is turned upright and released from the plastic film and hot glue. Hold one of the back legs and tip it on its side while pulling at the plastic film to release the hot glue with your other hand.

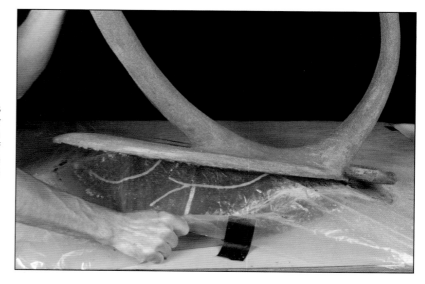

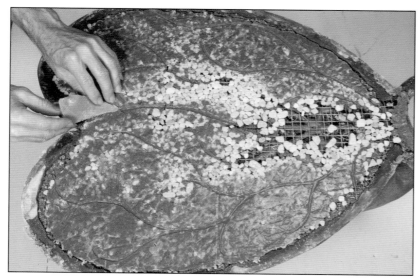

Removing Spacer: Remove the clay spacer and scrape off any oily residue.

Removing Loose Concrete: Remove loose concrete and marble chips in preparation for more concrete. A sculptor's hammer and chisel with a half-inch blade is best for cleaning up, but a cold chisel may work. The excessive concrete in the front transition from the top to the front leg is pictured being removed, so that it can be modified with new concrete.

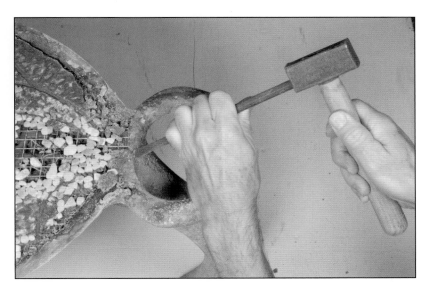

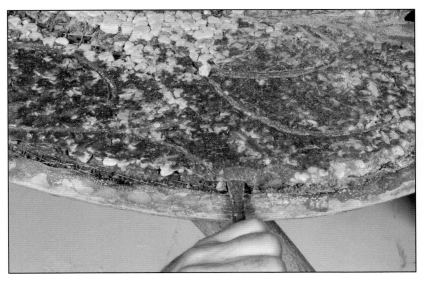

Chipping the Edges: Use the stone chisel to chip the concrete out from the re-bar closest to the edge. This will also provide a rough surface for more concrete to adhere.

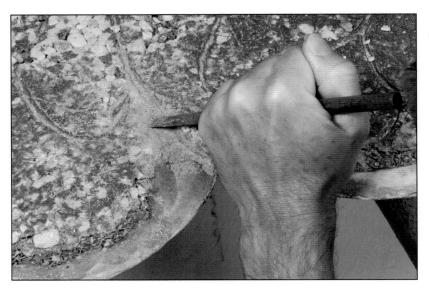

Shaping the Back: Shape the back where the wings cross. Make a smooth transition from where the clay spacer was to the anchoring cement edge.

Cleaning Up: Remove loose marble chips and spray the work off with a water hose to clean all dust and debris away. Tip the table to drain any standing water trapped in the cavities.

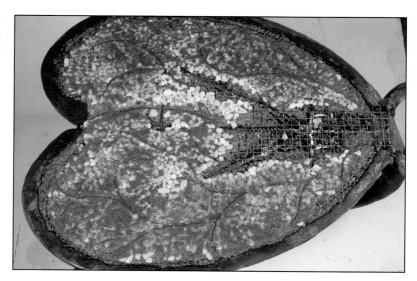

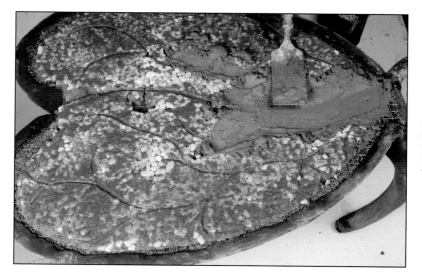

Applying Concrete to the Center: Mix six small trowels of dry concrete with water and apply some of it to the central area where the marble chips did not adhere on the first application.

Pushing Concrete into the Center: Force concrete into the crevices with your finger tips.

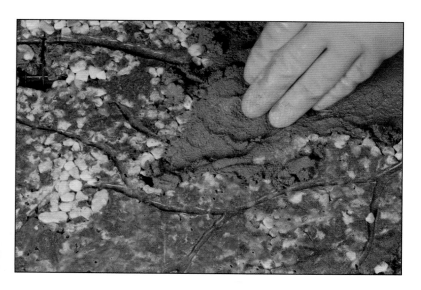

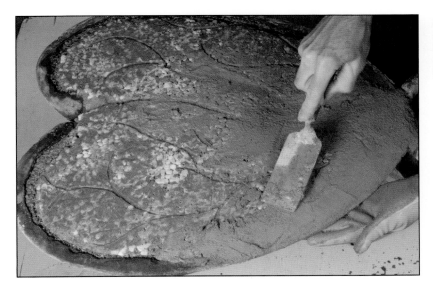

Applying Concrete to Edges: Work concrete into the edge area between the main body and the anchoring cement. Cover the anchoring cement so that it is level with the tabletop.

Adding Marble Chips: Add small marble chips to the central area.

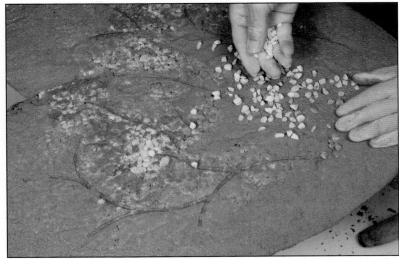

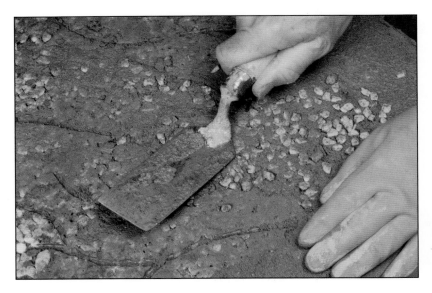

Pressing In the Marble Chips: Press the marble chips into the concrete with a rectangular trowel. Pat the concrete vigorously to settle it and eradicate air bubbles.

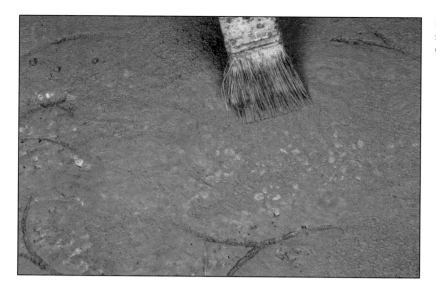

Brushing: With a two-inch paintbrush, smooth and brush away just enough concrete to expose the marble chips.

Dental Tool: The veins of the fly wing that were made with the hot glue may have filled or been obscured with concrete. Clean out the grooved impressions with a dental tool or small blade and reestablish them on the new concrete.

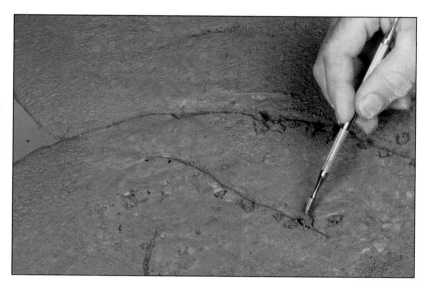

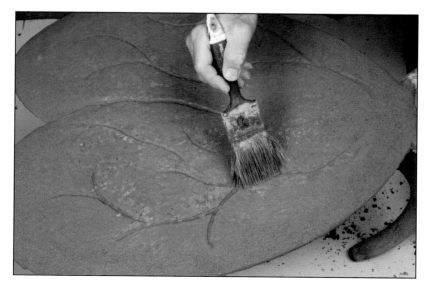

Brushing Out Waste: Brush away any loose debris.

Spraying the Legs: Spray the legs with water in preparation for more concrete.

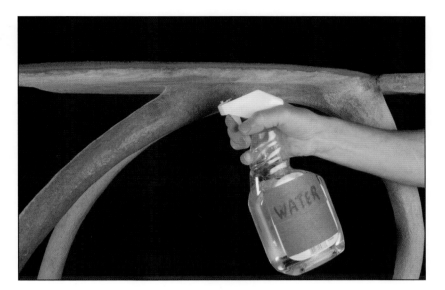

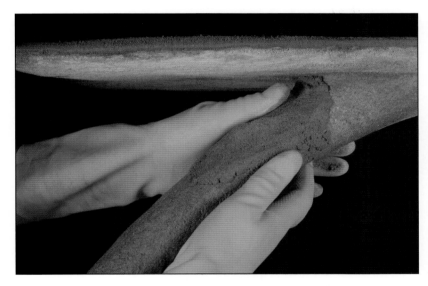

More Concrete on the Legs: Add about one-quarter inch of concrete to the top side of the back legs that were upside down or vertical in the first application.

Palette Knife: Use all the techniques for applying and modeling concrete described previously, such as patting with hands and brushing. A palette knife is useful for adding small amounts of concrete in low areas.

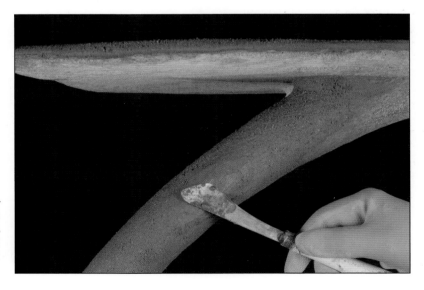

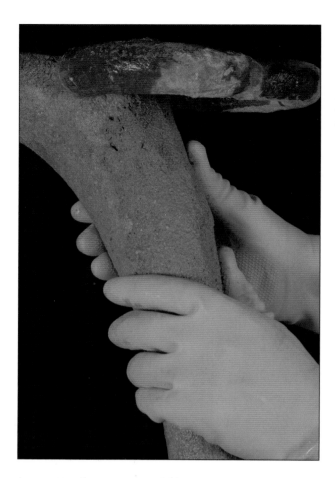

More Concrete on Front Leg: Add more concrete to make a smooth transition from the top to the front leg. Build up and taper the concrete on the leg to achieve perfect contour arcs.

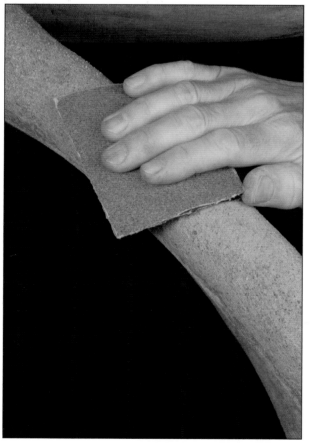

Wrapped and Bagged: After completing the modifications, wrap the table with damp rags and cover it with plastic bags.

Sanding Legs: After curing for one or two days, unwrap the table, and let it dry out for twenty minutes. Then lightly sand the legs with coarse sixty-grit sandpaper.

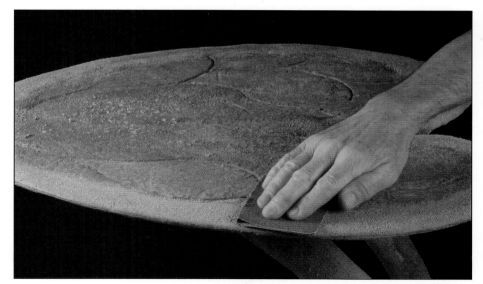

Sanding Top: Sand the top perimeter with coarse sandpaper to make the new layer of concrete flat with the top. Wrap the table in wet rags, cover with plastic bags, and let it cure for at least several more days.

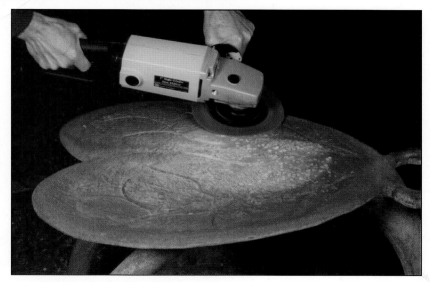

Power Sanding: After curing for a week, unwrap the table and let it dry. Power sand the top to expose the marble chips. Use a large side-grinder with a seven-inch, twenty-four-grit, flexible sanding disk. Work outside and wear the proper safety equipment: earplugs, dust mask, and face shield.

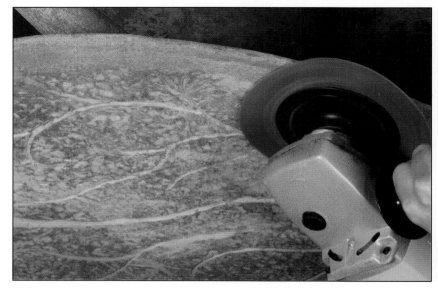

Power Sanding: Be careful not to gouge the top when power sanding close to the edge.

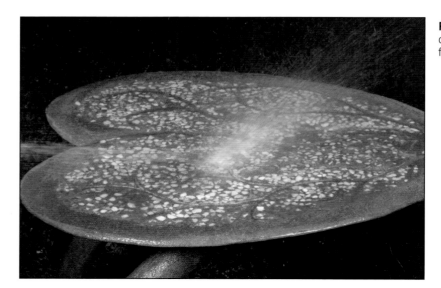

Rinsing Off: Concrete that is well cured can be rinsed off with water from a hose.

Checking for Flatness: Check the top for flatness with a straight edge such as a level.

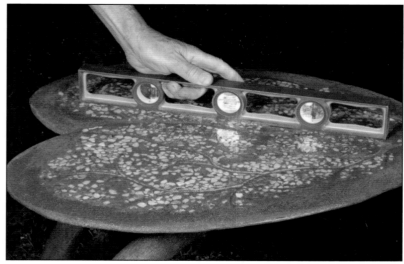

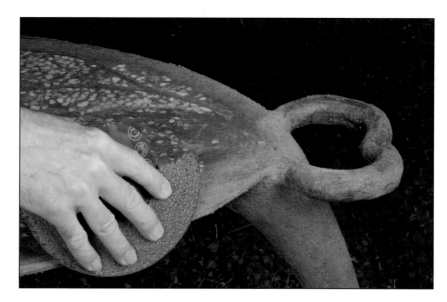

Sanding the Edge: With an old twenty-four-grit sanding disk, hand sand the edge until it is rounded and has a smooth arc.

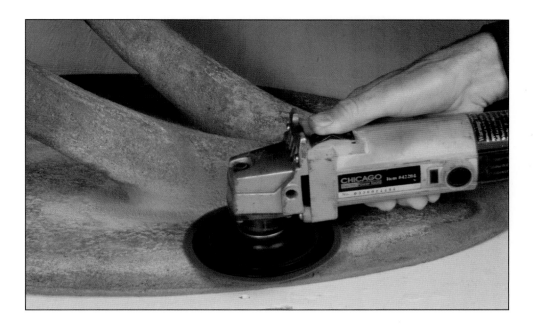

Small Grinder: The small side-grinder with a sanding disk is more maneuverable on the underside of the table. It also speeds up the process of locating wires or re-bars when they are near the surface.

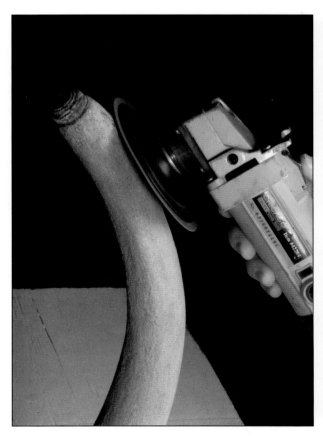

Power Sanding Front Leg: Be very careful using the small side-grinder on the legs because it can gouge and distort the profile quickly.

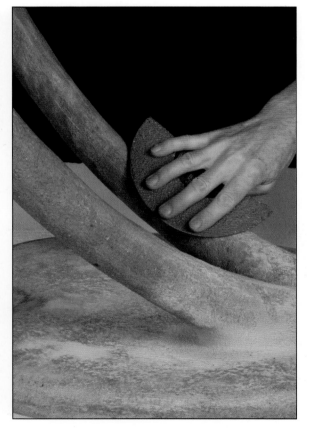

Hand Sanding Legs: Hand sanding with an old twenty-four-grit sanding disk is very effective in reducing high spots and shaping the legs. Because the concrete is cured and hard, more aggressive sanding is necessary.

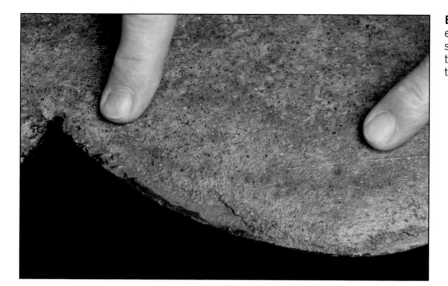

Exposed Wires: Locate and mark exposed metal and surface rust. Rust stains on the concrete are indications that wires or re-bars are just below the surface.

Grinding Out Wire and Re-bar: Grind out surface metal with the small side-grinder fitted with a hard grinding disk for metal. Angle the grinding disk so that it cuts a trench a quarter inch deep. Grind out all metal that is exposed or close enough to the surface to make rust marks.

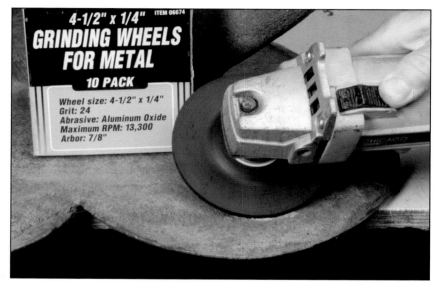

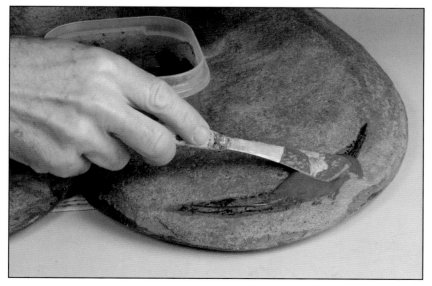

Filling with Anchoring Cement: Fill the cut out trenches with anchoring cement. Also use it to build up and sculpt low areas.

Brushing: Brush the anchoring cement so that it is smooth and flows seamlessly into the concrete.

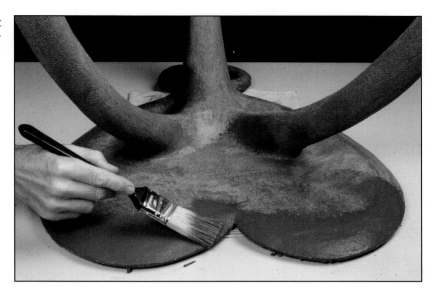

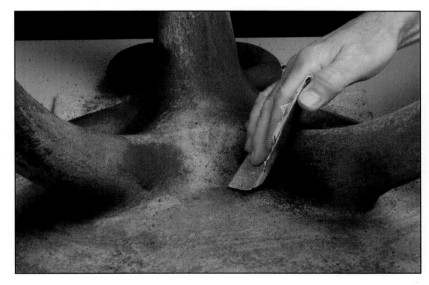

Hand Sanding: Two hours after the anchoring cement is applied it can be lightly hand sanded with sixty-grit sandpaper. The sandpaper will clog up quickly because the anchoring cement is still soft.

Sculpting with Anchoring Cement: Use anchoring cement and all the techniques for working with it to sculpt the front handle.

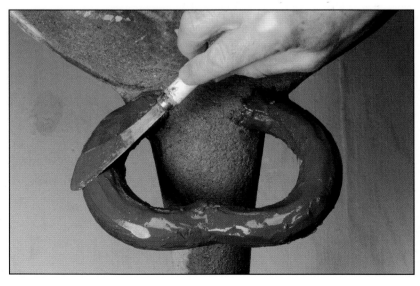

CHAPTER FIVE
FINISH: WATER

Finishing involves creativity, intuition, and chance. Various mixtures of cement, silica, dry pigments, inks, paints, and sealers are brushed on repeatedly and sanded off almost completely. The surface becomes smoother and the colors richer and more complex with every cycle.

The key to making concrete smooth is to apply several layers of what a ceramic artist would call a slip. The slip is made of equal parts of cement and ground silica and just enough water and fortifier to make a thin paste. Ground silica, also called silica flour, is available at ceramics supply shops. The slip is brushed on and can be a vehicle for color. It is allowed to cure a day or two, and then sanded almost completely off. It fills the low spots and the porous surface. Ink, pigments, and paint may be poured, splattered, and brushed on the slip at any stage for different effects.

A word of caution: Silica, cement, and dry pigments are hazards when airborne. A dust mask must be worn when mixing, sanding, and sweeping the work area. It is best to do all the sanding outdoors where the space can be hosed off when done. Health risks are serious; go to http://www.osha-slc.gov/SLTC/silicacrystalline/index.html for more information on ground silica.

Between bursts of creative activity, finishing is mainly a time for curing. The concrete and its finishes are kept damp and covered with rags, and water is strictly regulated. It is with *Water* that the *Fly Table* is born.

After curing for a month, the surface is etched by brushing on muriatic acid that is quickly rinsed off. An acrylic concrete sealer that repels water is brushed on to remove the chalkiness of concrete and gives it a slick finish. Dry pigments and paints can also be added at this stage to enhance the appearance. When the artist is pleased with the work, it is signed and prepared for the client and the art world's critiques.

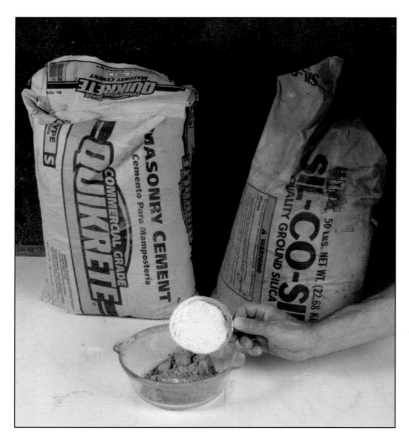

Slip Mix: The secret to making furniture with a smooth, marble-like surface is to brush on thick mixtures of cement and ground silica and sand them off. Ground silica, also called silica flour, is available at ceramics supply shops. In fact, the word "slip" is a ceramic term that was appropriated for a similar concrete process. To make a concrete slip, measure and mix one cup of masonry cement and one cup of ground silica. Always wear a dust mask when mixing and sanding; the health risks associated with ground silica are serious.

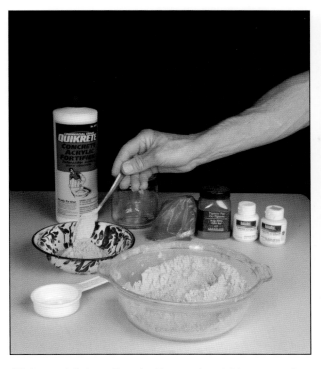

Mixing and Colors: Transfer three or four tablespoons of the dry mixture to a small dish. Shown in the background are some of the additives, pigments, and paints.

Fortifier: To enhance bonding, water can be combined with up to fifty percent Quikrete® Concrete Acrylic Fortifier. Mix only enough liquid for each color. In this case a quarter-cup of each liquid is sufficient.

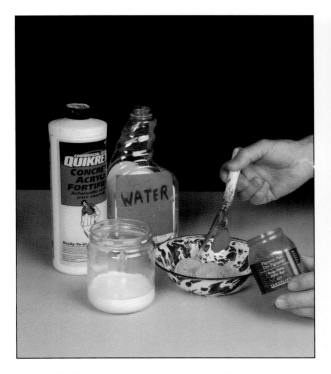

Adding Red Powder: Dry pigments are added and mixed into the dry mix of cement and silica. One teaspoon or palette knife of the red pigment is enough for the front leg slip.

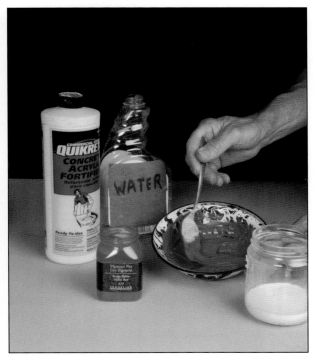

Wet Mixing Slip: Pour some of the liquid into the dry mix a little at a time, and stir to form a thick paste.

Spraying: Dampen the front leg with water from the spray bottle.

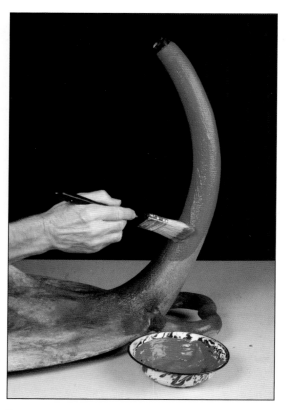

Brushing on the Slip: Use a small paintbrush to brush the slip on the front leg.

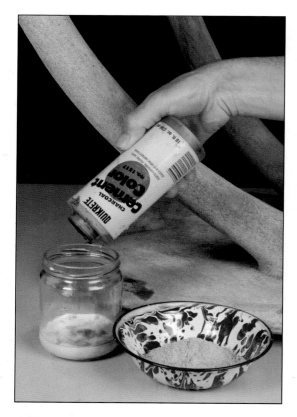

Adding Black: Transfer four or five tablespoons of dry mix to a small dish and prepare the fortifier and water. Add about a teaspoon of charcoal colored Quikrete® Concrete Color to the liquid.

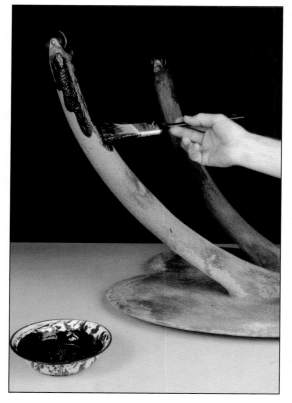

Brushing on Black Slip: Brush the black slip on the two back legs.

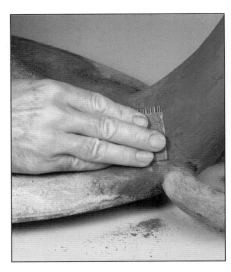

Sanding Red Leg: Sand the red front leg where it connects to the underside of the top, to create a transition zone. The sandpaper will clog quickly on the wet slip.

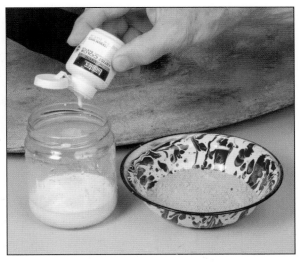

White Paint: Transfer six or seven tablespoons of dry mix to a small dish and prepare the fortifier and water. Add about a teaspoon of titanium white acrylic artist paint to the liquid mix.

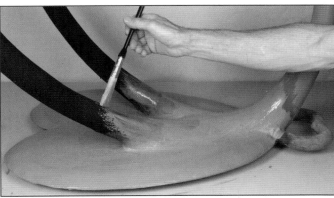

Brushing on White Slip: Mix the slip and brush it on the underside of the table. Extend the white slip a few inches over the base of the legs.

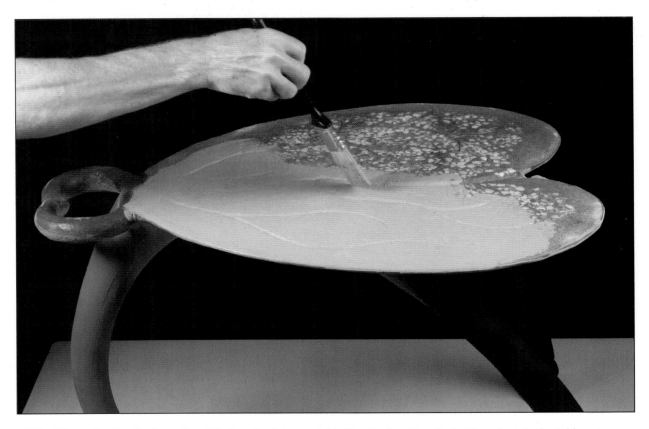

White Slip on the Top Surface: Carefully turn the table upright. Use the front handle to lift and rotate the table onto its back edge. Then transfer the weight to the wheels as it comes over. Dampen the surface and then brush the white slip on the top surface and the front handle.

89

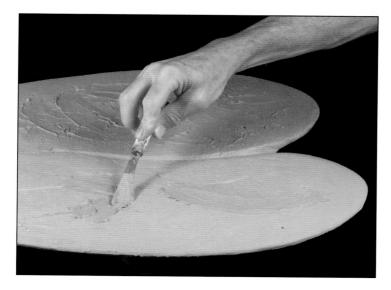

Spreading Thick Slip: The remaining slip in the dish will begin to get thicker as it absorbs water and sets. Use a palette knife to press the thick slip into the grooves on the top surface.

Brushing Out Thick Slip: Brush out the slip for a consistent finish. Mist the table with water and cover it with plastic for twenty-four hours.

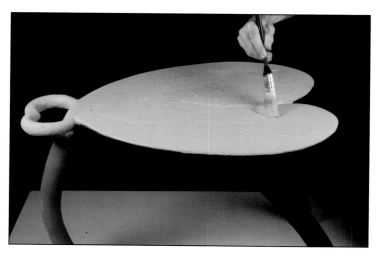

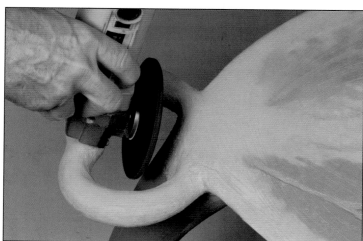

Sanding the Top: Sand the top with eighty-grit sandpaper until you can see the marble chips. Be sure to wear a dust mask.

Grinding Out Wires: The next day check if any wires or re-bar have rusted through the slip. If any are found, grind them out with the small side-grinder fitted with the hard abrasive disk.

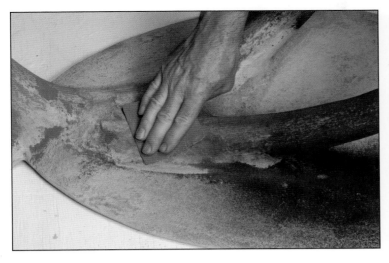

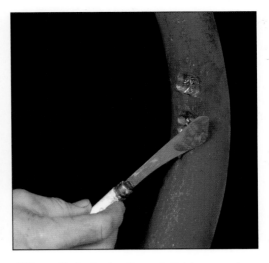

Sanding the Bottom: Turn the *Fly Table* over and sand the legs and underside of the top. When the sanding is done, rinse the table off.

Filling with Anchoring Cement: Patch areas where wires were ground out with anchoring cement.

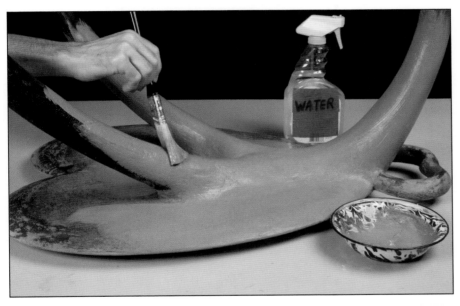

White Slip All Over: After the anchoring cement patches have set up, mix enough cement and silica with water, fortifier, and white acrylic paint to cover the whole piece. On the underside, brush it on everywhere except a few inches from the casters and the front handle.

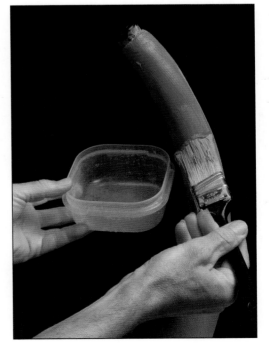

Red Pigment: Put some red dry pigment in a dish, dip a brush in the pigment, and apply it to the front leg in even strokes.

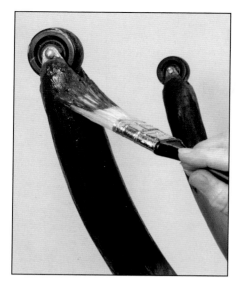

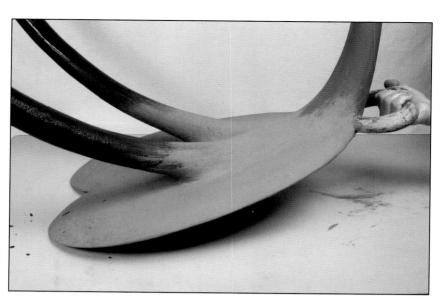

Black Slip: Separate a little of the slip and add just enough black concrete color to make it black. Brush it on the back legs starting from the casters and go over the white slip.

Turning Over: To turn the *Fly Table* over when wet, first lift it by the front handle, pivoting it on the back edge, and then over onto the wheels. Steady a wheel with one hand and flip the table upright.

White Slip on Top: Brush the white slip on the top.

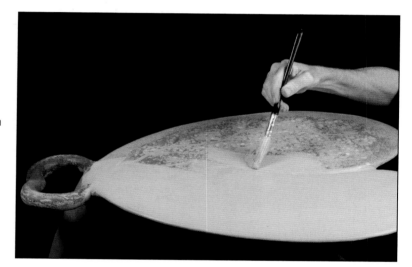

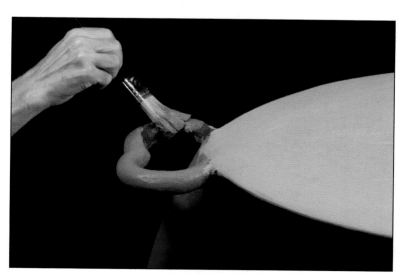

Blue Handle: Mix dry blue powder pigment in the last of the slip, and apply it to the front handle. Mist the piece with water and cover it with the plastic bags overnight.

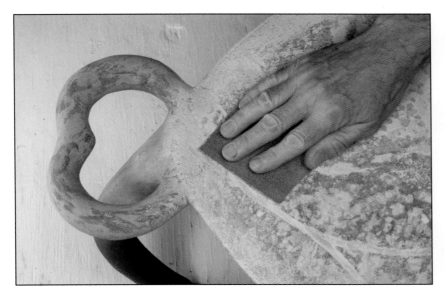

Sanding: After the slip has cured for a day, take the plastic off and let it dry out. Sand everything with eighty-grit sandpaper.

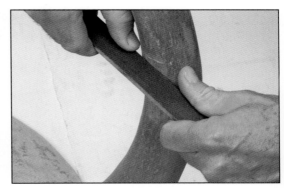

Filing the Hard Spots: Anchoring cement expands and is harder than the surrounding concrete. Use a sharp file to blend patches into their surroundings.

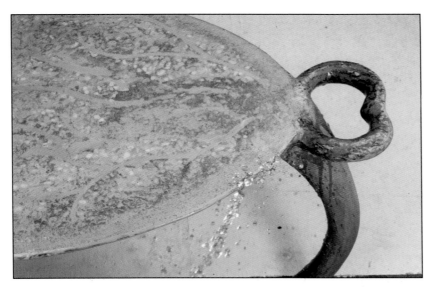

Rinsing with Water: Rinse the dust off and let the table dry for the next step.

Black Ink: To increase visual interest, splatter ink by putting some on a toothbrush and flick it off with a palette knife.

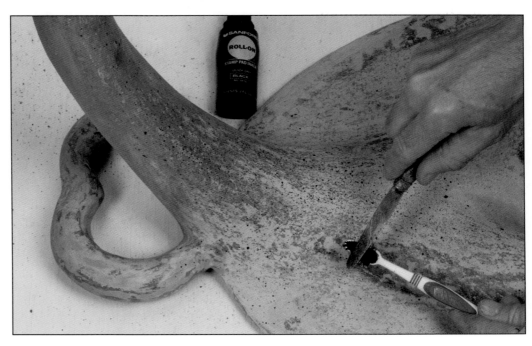

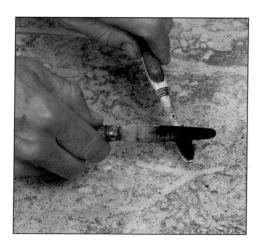

Black Ink on Top: Splatter the top with black ink.

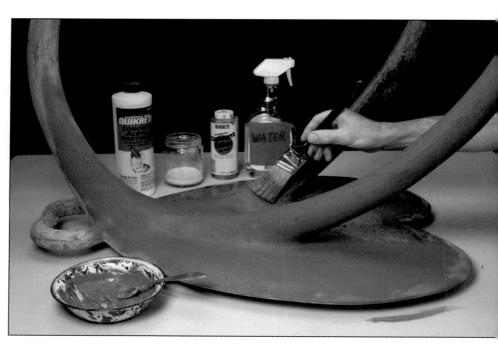

Gray Slip: Mix another slip with just enough black concrete color to make it light gray. Add a little more liquid than before so that it goes on thin and smooth. Starting with the table upside down, cover everything with the gray slip. This will create consistency and harmony between the elements.

Night Spraying: Keep the table damp and covered with the plastic bags overnight. It will absorb all the water in three or four hours, so spray it at least once during the night.

Blue Ink: The next day let the surface coat dry out, and then put blue ink on it before it is sanded. Drop ink directly on the front handle and spread it around with an artist brush.

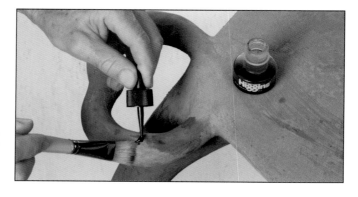

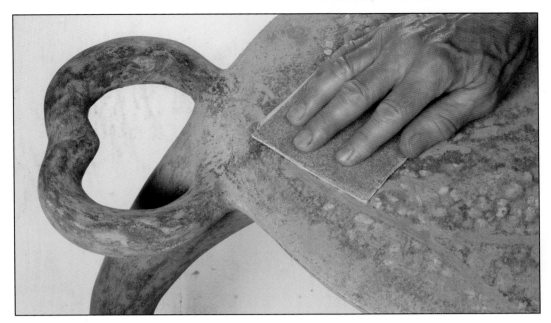

Sanding: Sand the entire table lightly with eighty-grit sandpaper. Expose the marble chips and eighty percent of what was underneath the gray slip.

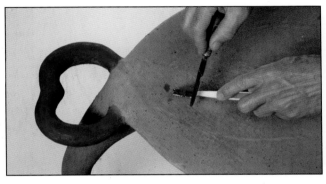

Blue Splatter: Use the ink splattering technique with the toothbrush and palette knife on the top and elsewhere. Most of the ink drips will be sanded off.

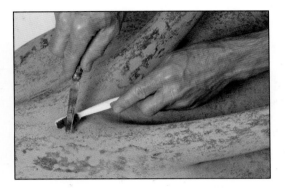

More Splatter: Dust the table off and splatter on more blue ink. After the ink dries, dampen by misting, wrap in rags, cover in plastic, and let it cure and harden for a few days.

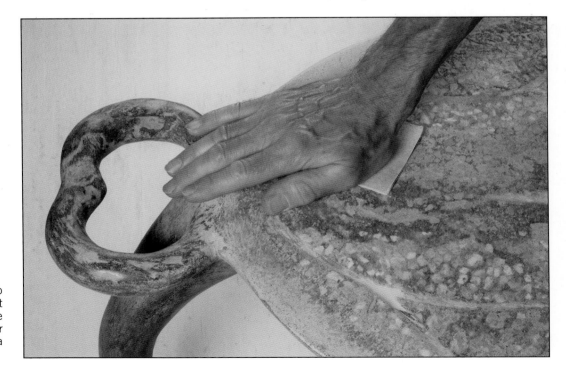

Sanding: After five days unwrap and remove the wet rags and let the table dry. Sand it with one hundred and fifty-grit sandpaper forcefully until the surface has a polished sheen.

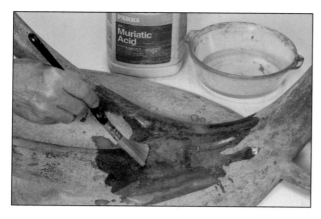

Acid Etching: Dilute muriatic acid with four parts water and brush it on the table quickly. The acid will froth up on contact and etch the concrete.

Rinse: Immediately rinse with plenty of water, so that the acid does not dissolve the slip coats. When it dries, the surface will feel like it has a slight roughness.

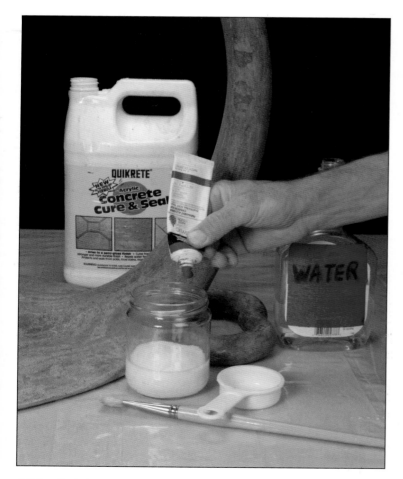

Mixing Red Paint into Sealer: Protect your work table with plastic film. Dilute one-forth of a cup Quikrete® Acrylic Concrete Cure & Seal with four parts water. Add and stir in one teaspoon of red acrylic artist paint.

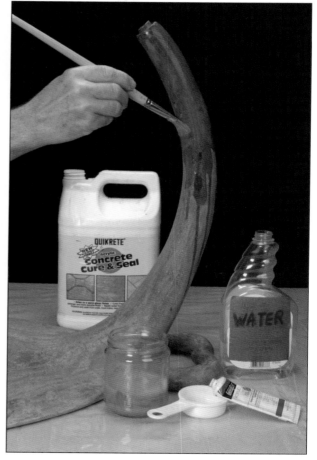

Brushing on Red Sealer: Brush the red sealer on the front leg beginning at the tip end and tapering it off at the intersection with the top.

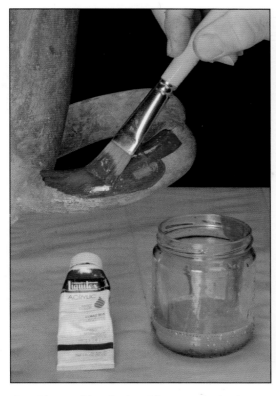

Brushing on Blue Sealer: Dilute one-forth of a cup of sealer with two parts water. Add and stir in a half teaspoon of blue acrylic artist paint and apply it to the handle.

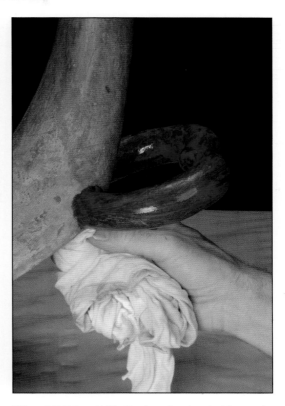

Wipe Off Drips: With the handle elevated for work, use a damp rag to wipe off any drips of the colored sealers that have run down to the top surface.

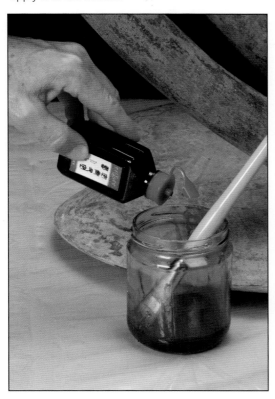

Adding Black Ink to Blue Sealer: Add a few drops of black ink to the blue sealer mix. The black ink will quickly be the dominant color but will retain a blue cast.

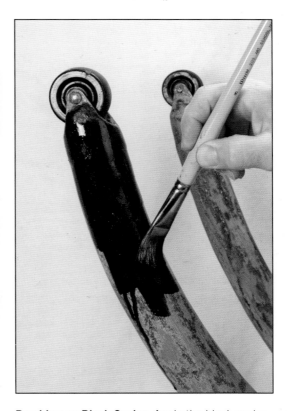

Brushing on Black Sealer: Apply the black sealer to the back legs starting at the casters.

97

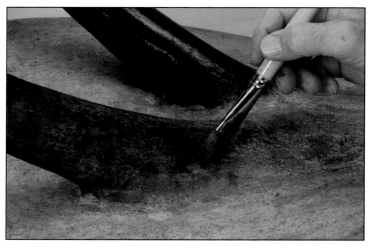

Dry Brushing: Using a brush that is almost dry, dapple the black sealer on the transition area where the back legs meet the top.

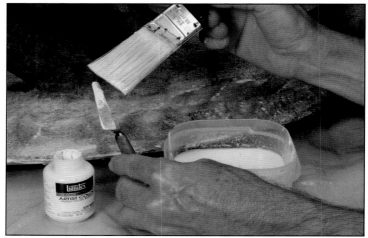

Putting Paint on a Brush with a Knife: Mix up some more sealer, diluting it with four parts water. Dip a paintbrush into the sealer mix, and then put Liquitex® soft white acrylic artist paint directly on the brush with a palette knife.

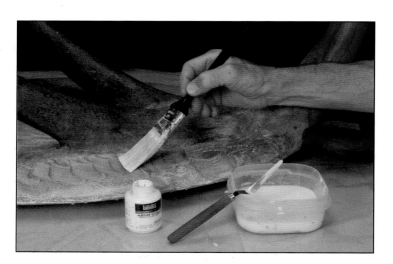

Brushing on White Sealer: Brush the white sealer on the underside of the top and the transition area of the legs with a swirling motion. The reason for using slightly different colors and diluting the sealer (binder) is to add complexity to the surface when some of the layers with color are sanded off.

Modifying with Rags: On the transition area of the legs, modify the intensity of the white sealer by lifting some off with a damp rag.

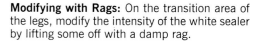

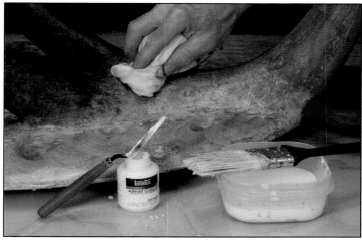

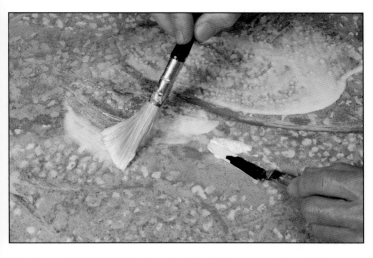

Brush and Palette Knife: Turn the *Fly Table* over and apply the white artist paint directly on the top surface with a palette knife. Mix the sealer with the paint and spread it around with a brush.

Sanding Top: The sealer dries quickly, so it can be sanded in an hour. Sand the entire table with one hundred and fifty-grit sandpaper.

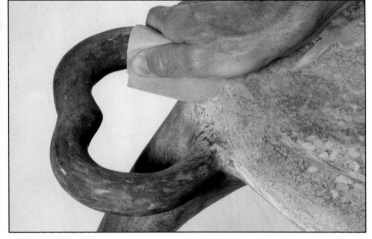

Sanding Handle: With the stronger colors on the handle and the legs it is easer to tell how much you are sanding off. In some areas about half of the finish will come off in the higher places, in others it will just be speckled with the underlying gray concrete.

Pouring in Pearlescent: Pour a half-cup of Quikrete® Acrylic Concrete Cure & Seal into a container and do not dilute it. Add and stir in about two tablespoons of Liquitex® Pearlescent Medium.

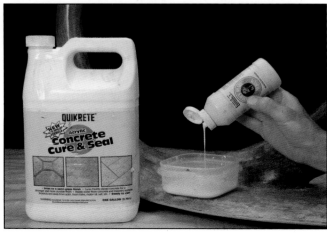

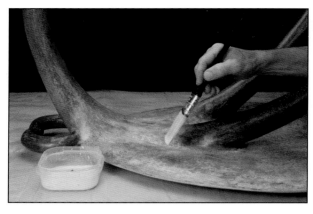

Brushing on Sealer: Brush the pearlescent sealer mix evenly over the entire piece. It is easer to do the underside first with the piece elevated off the plastic by a board, and do the handle last after the work is turned over.

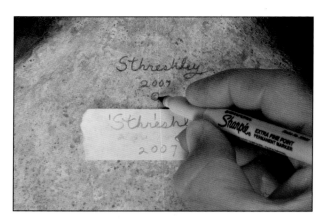

Signing the *Fly Table*: Measure, align, and place some white artist tape under where the piece is to be signed as a guideline. Sign and date it with a Sharpie® permanent marker.

Applying Paint with a Palette Knife: Apply another coat of pearlescent sealer mix. Begin with the casters on the back legs and blend in some stainless steel colored artist acrylic. Use less color down the legs and over the rest of the piece.

Modifying with a Rag: Modify the coverage of the stainless steel acrylic with a damp rag.

Final Sealing: There is just a trace of the stainless steel acrylic paint left in the third sealer when the top is brushed.

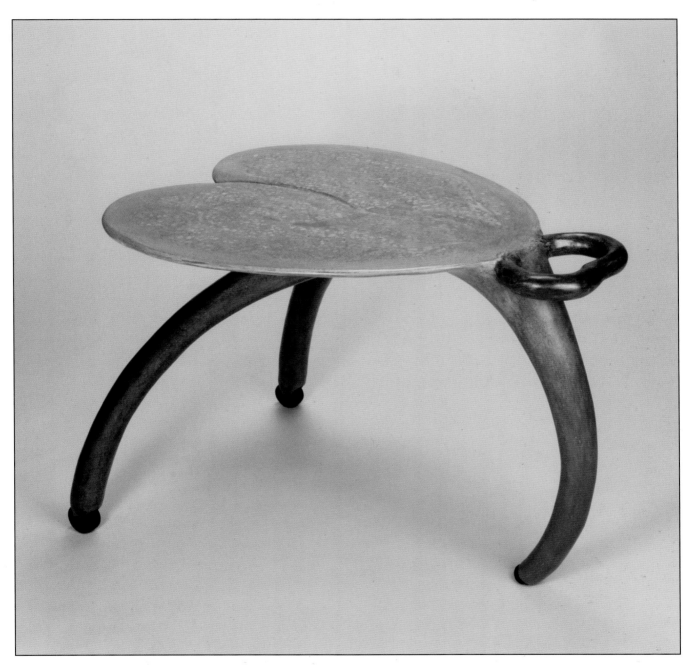

Fly Table, Concrete, wheels, 21" x 21" x 30", 60 lb., 2007

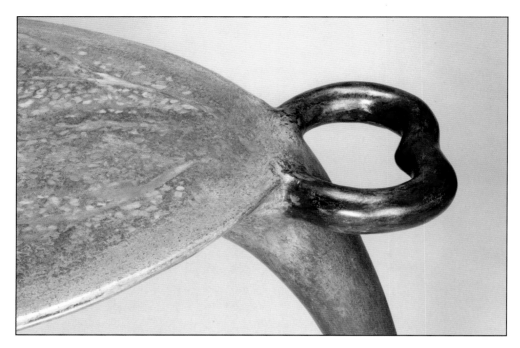

Fly Table, (detail) Concrete, wheels, 21" x 21" x 30", 60 lb., 2007

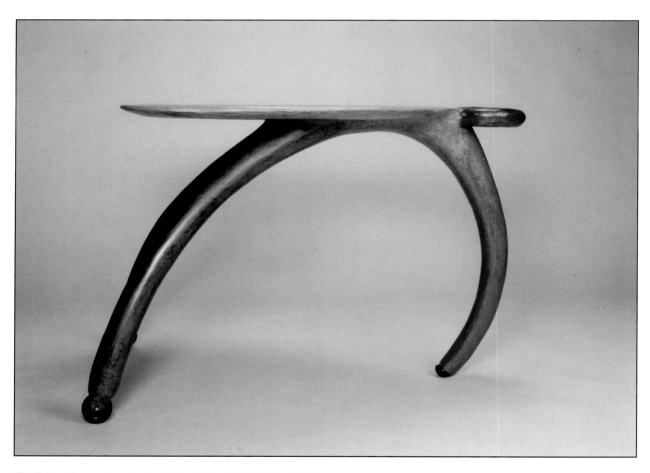

Fly Table, Concrete, wheels, 21" x 21" x 30", 60 lb., 2007

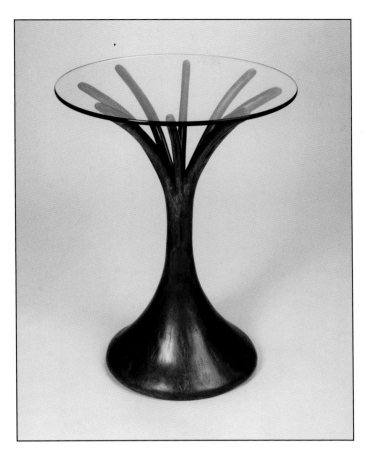

Palm Table, Concrete, glass, 29" x 20" x 20", 42 lb., 2003
Branch-like elements holding up the glass are made with anchoring cement over re-bar. On the top of the branch tips is a clear rubber material that prevents the glass from sliding. This table is well documented at www.concrete-art.com.

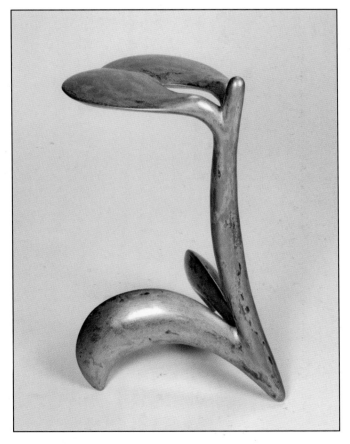

Silver Stand, Concrete, 21" x 13" x 15", 15 lb., 2002
A picture of this plant stand was featured on the cover of The Furniture Society's 2002 directory.

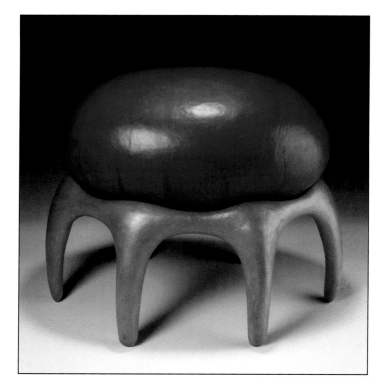

Blue Hope, Concrete, rubber, 19" x 22" x 15", 24 lb., 2001
The blue cushion on this stool is made from Plasti Dip®, a liquid rubber. It was applied over a theatrical scrim on foam and batting. For more information on how it was made go to www.concrete-art.com.

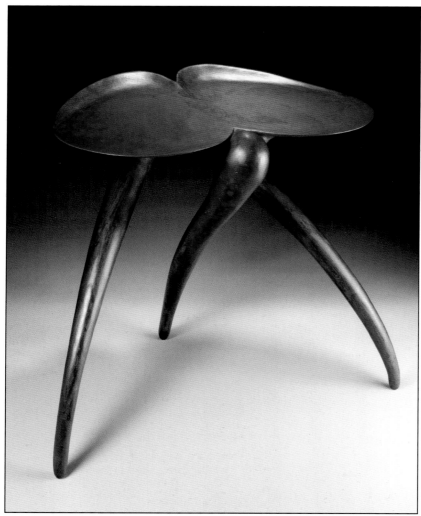

Nouveau Nouveau, Concrete, 27" x 32" x 18", 60 lb., 2001
This table was inspired by an exhibit on Art Nouveau at the National Gallery of Art in Washington DC in 2001. The goal in creating this piece was to take the paramount principles of Style 1900 and update them with a contemporary material—concrete.

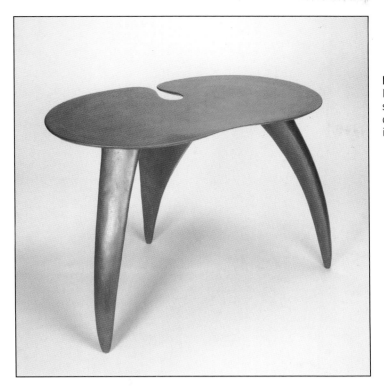

Laptex, Concrete, 27" x 40" x 21", 80 lb., 2000
Laptex is a desk for a lap top computer. It has a slot in the top where wires go down and are hidden behind a wide back leg. The concrete color is solid red with a surface of acrylic copper paint.

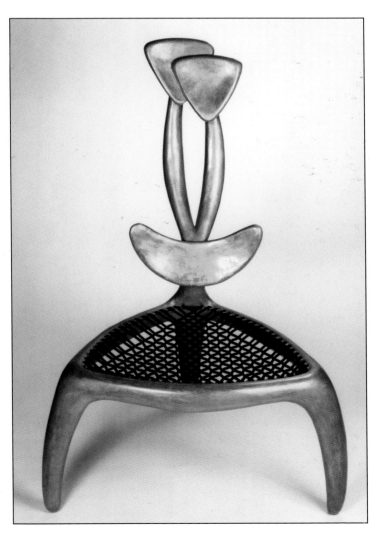

Crete Seat 2, Concrete, rope, washers, 49.5" x 31" x 29", 100 lb., 2000
This chair is made for the outdoors. The woven mountain climbing rope of the seat is secured by stainless steel washers. The base color is buff with metallic gold paint in the surface sealers.

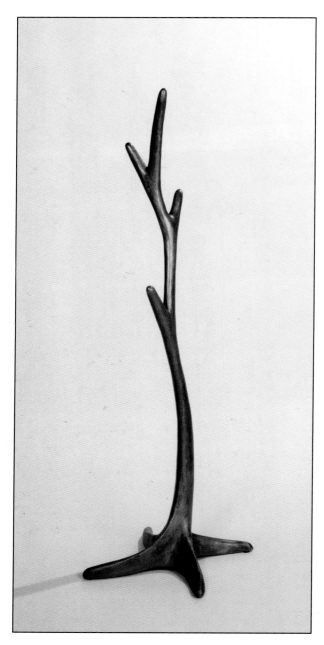

Coattree 3, Concrete, 58" x 22" x 22", 30 lb., 1998
This coat tree is part of a series of trench coat trees that
were inspired by pictures of battered battlefield trees in
World War I.

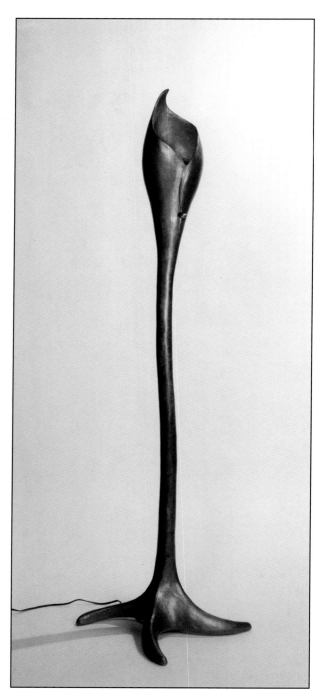

Plant Lamp, Concrete, 74" x 17" x 17", 45 lb., 1998
This troche is designed to look like a large flower bud. The
switch knob is made of anchoring cement, as is most of
the lampshade.

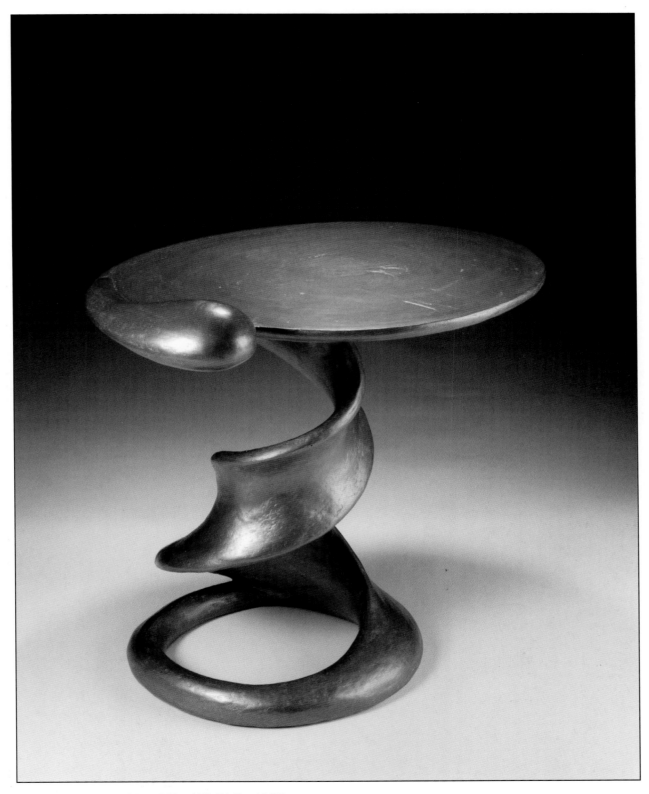

Heliotaxis, Concrete, 21" x 23" x 17", 50 lb., 1997
This small table is entirely supported on one spiraling column of concrete.

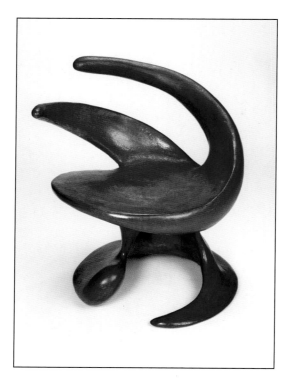

Vortex Chair, Concrete, 28" x 25" x 24", 90 lb., 1995
In this spiraling, asymmetrical chair the backrest becomes an armrest. It was exhibited at the Smithsonian Institution in 1999.

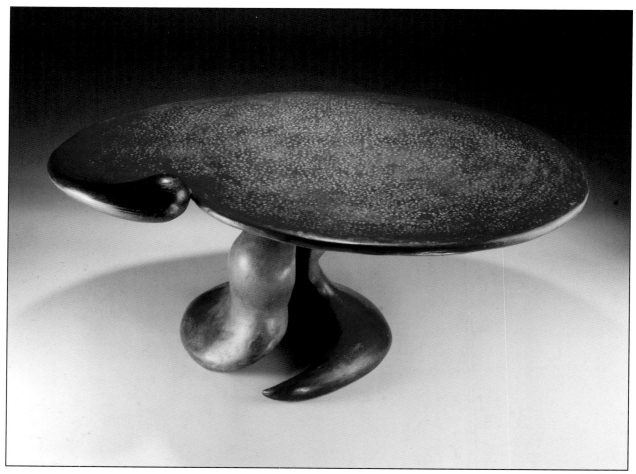

Nebula, Concrete, 16" x 36" x 26", 85 lb., 1997
Nebula has a terrazzo top surface like the Fly Table. The base is hollow and spirals.

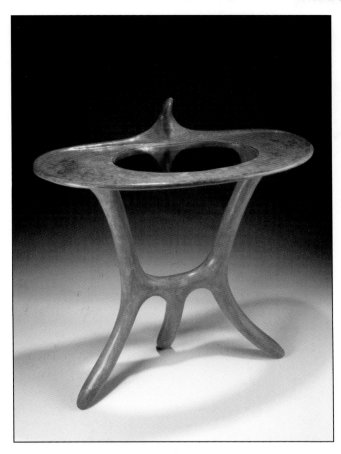

E-Table, Concrete, glass tray, 26" x 23" x 18", 75 lb., 1995
This entertaining table was designed to support a light meal for two on a small balcony. Most of the top is a void when the glass tray is removed for serving. Other radical features are: the back leg comes forward and the front legs go back. E-table is pictured in the first journal published by The Furniture Society, *Furniture Studio the Heart of the Functional Arts*, 1999.

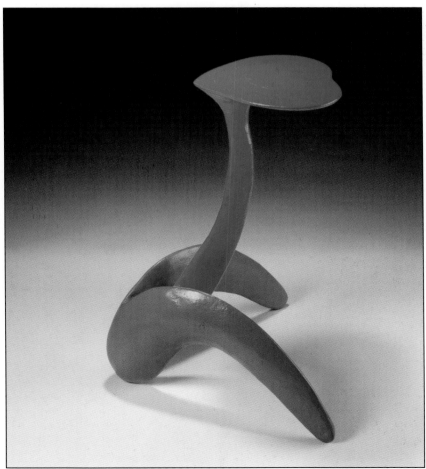

Sweetheart, Concrete, 21" x 16" x 17", 25 lb., 1995, *Courtesy of Marty Jones*
This is one of a series of four plant stands that were made with the aid of a jig, so that the re-bar dimensions would be the same.

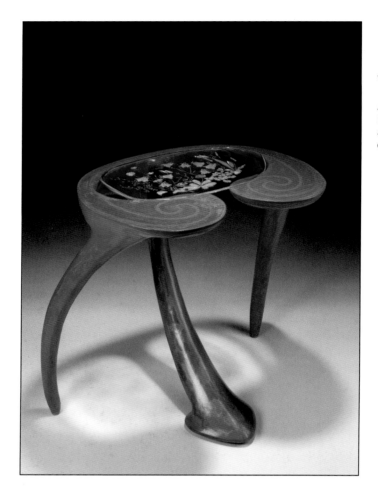

Wall Hall Table, Concrete, glass, 41" x 37" x 16", 100 lb., 1992
A recessed ledge holds the glass insert. When it was constructed and cast on its top surface, a plywood form held the place for the glass and opening.

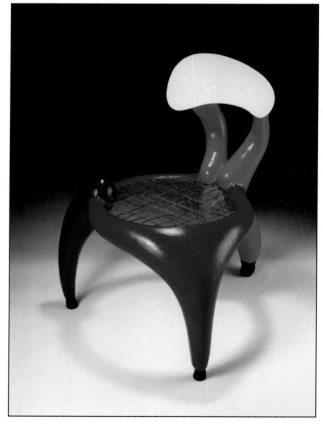

Wishbone Chair, Concrete, steel, 29" x 22" x 25", 60 lb., 1992
Wishbone Chair has a sheet metal backrest that was formed by beating it with a ball peen hammer. The seat was made by weaving different size galvanized steel wires. There is a caster on the back leg to aid mobility.

Flashback, Concrete, flat bar, wheels, 20" x 40" x 16", 60 lb., 1991
This table has two surfaces. The top surface is concrete and the bottom one is made of a progression of metal flat bars.

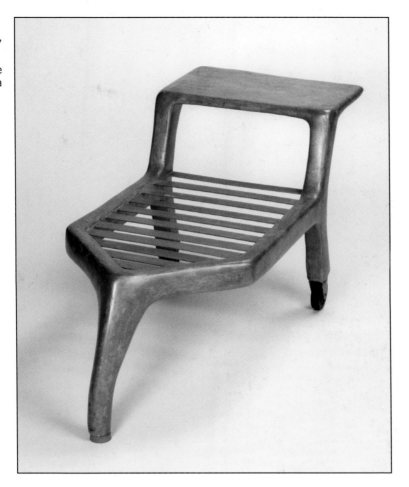

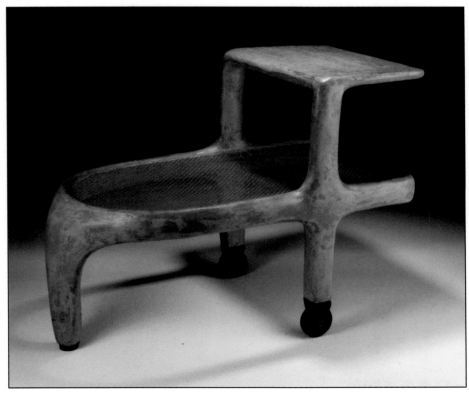

Shuttle, Concrete, hardware cloth, wheels, 23" x 32" x 17", 65 lb., 1990
Shuttle is a coffee table/hassock. The lower surface is open quarter-inch hardware cloth that can be covered with a cushion to make a footrest.

111

CHECK LIST OF TOOLS AND SUPPLIES

TOOLS

Electric arc welding machine also called a stick welder or buzz box.
Reciprocating saw with a fine tooth metal cutting blade.
Cut-off saw with an abrasive metal cutting disk.
Oxygen-acetylene cutting torch
Large vice
Welding clamps such as Vicegrip® C-clamps.
Spring clamps
Magnetic right angle securing devices for holding re-bars during tack-welding.
Slag hammer
Wire brush
Wire cutters
Sheet metal shears
Needle nose pliers
Hot glue gun
Masonry trowels: a small five-inch pointed trowel for dry and wet mixing and the application of concrete, and a small five-inch square end trowel for scraping the wet mix on the sides of a bucket.
Wood rasp for shaping concrete.
Five-gallon buckets for dry mixing.
Three-gallon bucket for wet mixing.
One quart **bowl** for mixing the slip.
One pint **plastic container** for mixing the anchoring cement.
Palette knife for mixing and applying anchoring cement.
Dental instrument or pointed tool for picking out concrete in crevasses.
Two-inch **paintbrush** for smoothing the wet concrete and applying the slip.
Clean **paintbrush** for applying the sealers and colors.
Air compressor with sprayer.
Spray bottle of water.
A stone sculptor's **hammer** and **chisel**.
Small **round file**
A **bench grinder** is not essential but may be useful.
Small **side grinder** with flexible **sanding disk** and a **hard disk** for grinding metal.
A **wire cup brush** attachment is also useful for cleaning re-bar.
A large **side grinder** with a seven inch flexible **sanding disk** is useful for sanding large flat areas like the tops of tables.
A small **combination sander** with a six-inch sanding disk and four inch wide sanding belt is not essential but was used to shape and smooth parts of the model.
A **scroll saw** was used to cut out the model.
An **electric concrete mixer** is not essential but may be useful for dry mixing on large projects.

SUPPLIES

Reinforcement bars (re-bars)
Welding rods, three-thirty-seconds and one-eighth of an inch 6011 flux coated rods.
Spray can of **bare metal primer** for the armature.
Leather gloves for metal handling and welding.
Neoprene gloves for applying the concrete to the armature.
Dust mask
Ear plugs
Face shield
Chicken wire
Hardware cloth, quarter-inch and half-inch.
Scrub brush and detergent for cleaning oil off the hardware and chicken wire.
Eighteen gauge **steel wire**
Hot glue sticks
Plastelene
Cement, type I & II gray Portland cement or type N mortar mix.
Sand
Quikrete® **Anchoring Cement**
Quikrete® **Concrete Colors**
Quikrete® **Concrete Fortifier**
Quikrete® **Concrete Sealer**
Powdered pigments
Artist acrylics paint
Ink
Rags
Paper towels
Kraft paper
Carpenter's glue for the wood model.
Painters tape
Duct tape
Six mil **plastic film**
Sandpaper, in fifty, eighty, one hundred, and one hundred and fifty grits.
Muriatic acid for etching concrete.